A Feast for
the Eyes

Carolyn Tillie

A Feast for the Eyes

EDIBLE ART
FROM
APPLES TO
ZUCCHINI

REAKTION BOOKS

'A' is for Andy – paramour extraordinaire
'B' is Becca and Bacon – Daughter, Don and Laura
'C' is for Calman – a really cool clan
'D' is for Dio – she knows why

.

.

.

'Z' is for ZeBot – a zebra angel with wings

Published by Reaktion Books Ltd
Unit 32, Waterside
44–48 Wharf Road
London N1 7UX, UK
www.reaktionbooks.co.uk

First published 2019
Copyright © Carolyn Tillie 2019

Printed and bound in China
by 1010 Printing International Ltd

A catalogue record for this book is available from the British Library
ISBN 978 1 78914 063 7

Contents

Introduction

·

The phrase 'food art' often brings to mind elaborate Flemish still-life paintings of the seventeenth and eighteenth centuries. In sumptuous, velvety tones, half-peeled lemons sit next to a lobster, predominant in Abraham van Beijeren's *Banquet Still-life*. Bright crimson from being freshly boiled, the lobster's claw seems to clutch a pristine white napkin draped over the edge of a table. The first course set, the crustacean is flanked by fine glassware brimming with wine, silver platters arrayed with carved meats, rare Delft porcelain spilling over with ripe fruit, all atop a lavishly woven tapestry. The imagery of food in works of art is a fertile field. Many museums and galleries around the globe have staged exhibitions devoted to the theme, and dozens of books exist on the subject.

But this is a book about food – that stuff you physically eat – *as* an art form. The concept has been much debated, both among the literati of the art world who stage exhibitions made up of 'foodstuffs' and by food writers who analyse the latest artisanal plating of duck leg confit by a celebrity chef. At their core, both food and art excite multiple senses and explore themes of consumption, ritual, culture, transformation and desire. Art is mostly savoured by the eyes and food by the mouth, but all the other senses may contribute. Being responsive to sensual experiences lies at the core of artistic awareness.

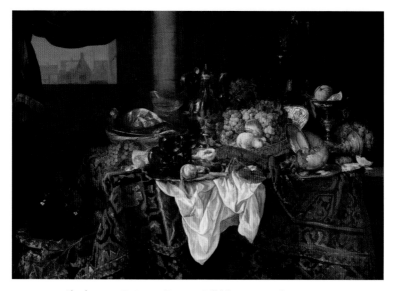

Abraham van Beijeren, *Banquet Still-life*, *c*. 1667, oil on canvas.

There is great similarity in discussing both food and art, as the descriptive adjectives are easily interchangeable: heavenly, enticing, disgusting, beautiful, tender, dazzling, dull, fragile, weak, strong, elegant, harsh and delicious. The language of one is the language of the other. Art *nourishes* the soul, profound art *satisfies*, and those who appreciate fine art have *great taste*. People *hunger* for beautiful things as they hunger for sustenance; art *feeds* the soul, while food nourishes the body. When approaching the visual arts that involve food, the viewer must literally take a sensual journey. Contemplating a tasty dish put before you, the first experience is visual, transitioning to anticipation of flavour, and then – when the aroma hits the nose – expectation of taste and flavour culminate with the experience of texture on the tongue. The aroma of the dish helps develop the expectation of taste.

Those same processes occur when you see a work of art that has been created from food. Is it meant to be eaten? Sometimes yes; oftentimes no. Just as pictorial or visual arts have evolved from being

representational, to expressing an idea, and ultimately to driving one to question his or her own perceptions, so food as art challenges the viewer's own perception and definitions of what is food and what is art.

Food is an innately familiar substance. As part of our everyday existence, its sheer necessity transforms it from the physical and practical level to one where it can be contextualized based on its usages. Everyone has a relationship with food, be it consumed in a social setting or as a solitary meal. On some ineffable level, it permeates global thought. It can entice and delight or repulse and offend. Memories of food eaten in our childhood can invoke either joy or disgust. It is those memories and feelings that make artworks created from food so enticing.

Most of us have happy childhood memories of playing with food: dyeing Easter eggs or stringing popcorn and cranberries on threads to make a Christmas tree garland. Imaginary kingdoms of mashed potato mountains and carefully landscaped, uneaten vegetables have appeared on children's plates from time immemorial. As a kid, when I ate my morning bowl of Froot Loops, I would devour all the green ones first so that the colour spectrum left in the bowl would be more pleasing to me – complementary, as it were – red, yellow, orange and purple. Green just didn't belong. For many children, their first introduction to art is through crafts created at holidays with family or in the classroom. Food is often the chosen medium because it is affordable, fun and easy to clean up. Summer camps include lessons in carving potato stamps or fashioning picture frames into Father's Day gifts from dried macaroni glued down into Art Deco patterns and joyfully spray-painted with gleaming, gaudy gold or silver.

In the 1970s, food and crafts were an essential part of my childhood. When my older sisters were knotting macramé purses and vests or weaving together bubblegum wrappers into long chains, I used red licorice vines to macramé edible bracelets. Using a toothpick, I pushed a hole through squishy gumdrops so that my 'jewellery' would be festooned with colourful, edible 'beads'. My mother decorated cakes to

match party themes, piecing together a cartoon bunny from sections of sheet cake and bringing it to life with shredded coconut fur, blushing strawberry cheeks, and a little frosting to coax a whiskered smile. On Sunday mornings, the kitchen was my father's domain as I smiled down at pancakes with blueberry faces grinning back at me.

Years later, in art school, I experimented with food assemblages and installation pieces. After studying jewellery-making and metalsmithing, my curiosity in food as art was intensified as more food-themed art exhibitions showed up in major museums and galleries. Food incorporated within the confines of what is considered 'high art' had hit the respectable mainstream. After this, I attended cooking school and in learning new techniques, my interest in the subject-matter increased, as did my own artistic output, now mostly food-themed.

It is easy to see how the concept of food as art gets its start – this playing with our food to make it look fun, enticing or different from what it is. For most, food art might simply be a good-humoured way to encourage kids to eat something they would rather not – or to enhance a table setting with a festive holiday arrangement. The advent of social media has launched hundreds of websites and videos instructing parents in imaginative tasks consisting of everything from creating a diverse selection of whimsical kids' snacks to decorating elaborate cookies, carving a watermelon into a whale-shaped bowl or arranging cupcakes into a colourful bouquet.

This may lead you to wonder: when did it all begin? At what point did food and art converge? The truth is surprising. They started together. Food as a consumable *and* as an art form have been intimately intertwined since the dawn of man. Both food and art are precious commodities – and the oldest-known art was constructed from a left-over meal.

Food in Art History

In the 1500s, the Italian painter Giuseppe Arcimboldo (1527–1593) created something that had never been seen before and would not recur again until the Victorian era. His paintings featured 'composite heads', a visual palindrome in which the character's portrait is composed of the very item it is associated with: a librarian fashioned from books, for example, or the Roman god of plants made up entirely of fruits and vegetables. *Vertumnus* is actually a portrait of Arcimboldo's patron, the Holy Roman Emperor Rudolf II (1552–1612), as the vegetable deity. Arcimboldo's style of art, known as Mannerism, emphasized an exaggeration of classical proportion, and balance and was often artificially elegant.

Starting in the mid-1600s, food would become the focal point for its own genre in the form of still-life paintings. The still-life continues to be an important thematic motif in its own right, but food *as* art is entirely different. It is taking an actual food item that you might have had for breakfast and transforming it into a piece of art worthy of being seen in a museum. For example, contemporary artist Klaus Enrique re-envisions Arcimboldo's *Vertumnus* with real food – rosy cheeks with apple, a prominent sweet potato as a ruddy nose, and brooding pea-shoot eyelids furrowing his brow.

Many art movements can seem intimidating to the uninitiated. In viewing Jackson Pollock's drip paintings or Mark Rothko's floating squares of saturated colour, because there is no recognizable subject-matter, many reject Abstract Expressionism as an art form. The great thing about works of art that have been created *with* food is that they are immediately accessible to everyone because we are already familiar with the edible ingredients used to create the artworks. These can be rep-resentational, as in the still-life lobster dinner. A more modern mind may conjure the multiples of Andy Warhol's Campbell's soup cans or the

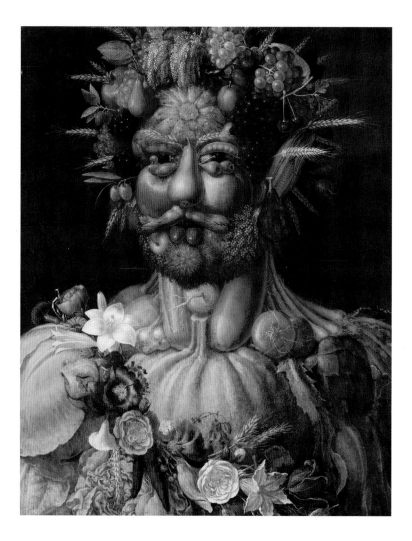

Giuseppe Arcimboldo, *Vertumnus*, 1590, oil on panel.

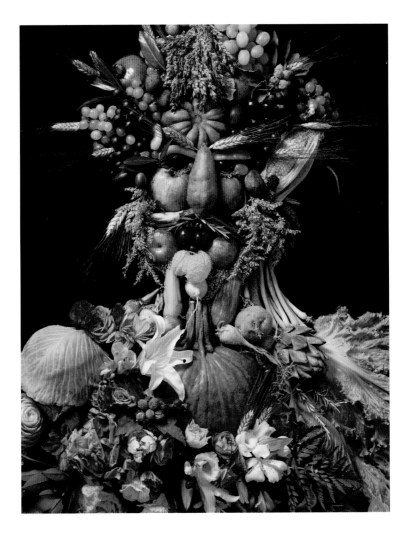

Klaus Enrique, *Vertumnus*, 2015, photograph.

stuffed hamburgers of Claes Oldenberg which, although vastly larger than their kitchen counterparts, at their core are representational.

Conceptual art is more difficult to define, having emerged as a fully fledged art movement only in the past half century or so. Its genesis is generally believed to be 1917, when Marcel Duchamp submitted a porcelain urinal to display in an art exhibition. Signed 'R. Mutt' on its side and titled *Fountain*, this 'readymade' artwork changed how everyone looked at what could be considered art. For the artist, the idea – or *concept* – of what is being presented took precedence over its potential appearance. An example of conceptual food art is Roelof Louw's *Soul City* (1967), in which 5,800 oranges were arranged on the floor of a museum, stacked atop one another in a perfectly symmetrical pyramid. Measuring a little more than 1.5 metres (5 ft) in diameter, the 'concept' was for visitors to take an orange if they wanted, so that the artwork would change and slowly dematerialize. The remaining fruit was left to rot and turn mouldy. The art was not a static depiction of the orange itself, but a dynamic embodiment of the themes of deterioration and the fleeting passage of time.

Trompe l'œil – French for 'trick the eye' – is a technique that engages the viewer in visual illusions or jokes. In paintings, *trompe l'œil* subjects are created with such photographic realism as to convince the viewer that the objects being seen are in three-dimensions. A classic example of two-dimensional *trompe l'œil* is a mural painted on a wall to give the optical illusion of more space, be it an intimate garden setting with an inviting al fresco bistro table and chair or a vast vineyard landscape framed by a fictitious grape arbour. In food, the art of *trompe l'œil* easily translates well into playful Halloween sugar cookies and biscuits, rolled and shaped to look like a witch's finger, and made sinister with a sliced almond as a menacingly pointing fingernail. Consider the modern wedding cake. The once simple, three-tiered white cake has now become a statement piece designed to reflect the interests of the couple getting married, often with great humour. Fully intended to be

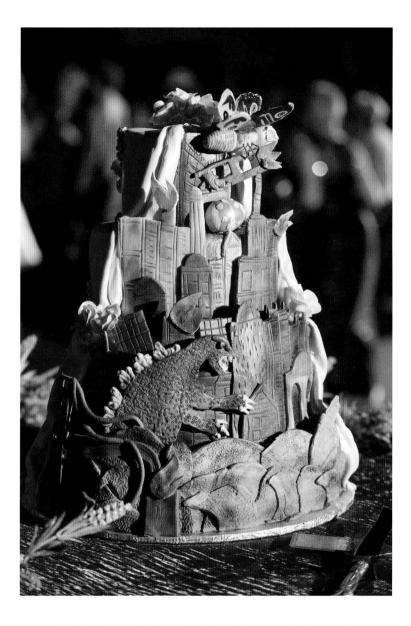

Tina Zettel/Willow Tree Bakery, *Godzilla Eating San Francisco*, 2016,
wedding cake.

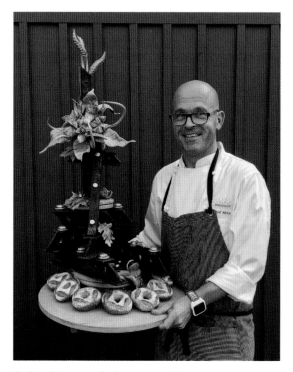

Chef Ciril Hitz proudly displays one of his showpiece creations.

eaten, exemplars in fondant and frosting are playfully sculpted into any imaginable scene, from Godzilla destroying San Francisco to a hyper-realistic goblin.

In exploring the world of food art, there are those offerings which are created with the intention of being consumed – such as the cake – versus those which should never be eaten, even though they are assembled with edibles. On one end of the spectrum, pastry chefs create realistic-looking cakes knowing their creations will eventually be consumed. These same pastry chefs channel their skills in professional competitions to produce extravagant showpieces of spun and pulled sugar, formed and baked bread dough, or moulded and sculpted chocolate. These masterpieces are *not* intended to be eaten, but are

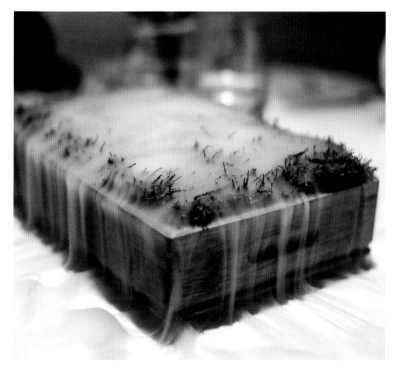

The Fat Duck restaurant, *5th Course*, 2009, oak moss.

instead simply marvelled at for the chef's ability in planning and exe-
cuting shapes, structure and colour combinations using malleable,
appetizing materials.

At high-end bastions of haute cuisine, new culinary philosophies
have chefs trading their saucepans, gas stoves and baking ovens for
immersion circulators, vacuum tumblers, sous-vide machines and
ultrasonic baths. These new tools offer innovative techniques that
make Michelin-starred restaurant kitchens look like scientific lab-
oratories, producing plated offerings that are ephemeral works of art.
Extraordinary care not only goes into the flavours being combined
on the plate, but into the combination of textures, balance of colour
and use of negative space. Instead of artists wielding a palette and

Leah Rosenberg, *Taste of Color*, 2016, performance at
Irving Street Project, San Francisco, California.

paintbrush, these chefs have precision tweezers for the minute place-
ment of single leaves of micro-herbs as a garnish, or a culinary syringe
with which to add a flourish of sauce.

At the other end of the food-as-art spectrum are artists who use
food as a medium but have no formal culinary training. Visual painters,
sculptors, installation artists and performance artists are choosing to
incorporate food into their creations. A choice few museums and gal-
leries have even begun to stage special exhibitions going beyond the
visual presentation of artworks that contain food, featuring interac-
tive, multi-sensory offerings where the viewers not only see, but smell,
touch and taste the artwork.

London-based artist and food historian Tasha Marks stages collab-
orative events with well-known museums that invite the audience to

participate in the creation of Renaissance sugar sculptures or partake in an 'aroma tour', pairing visual artworks with the sense of smell. Leah Rosenberg, artist and pastry chef, creates installation/performance art events in which she challenges participants to question flavours and colours as they experience her chromatic creations as cakes or cocktails.

Ancient to Medieval History: The Utilitarian Era of Food Art

Forty-thousand-year-old cave paintings have long been thought to be the oldest example of man's first attempt at creating art. But a full 20,000 years before the Neanderthal painted on a cave, he or she was creating art with food. Stealing an egg from an unsuspecting ostrich nest, our early ancestor bored a single hole into the large egg and poured out the insides to cook a substantial, communal omelette. After rinsing out the egg's interior, the empty shell was carved with geometric engravings – possibly tribal or clan markings – and then re-filled with water, utilizing the hollow egg as a canteen. The discovery in 2009 in South Africa of over 270 eggshell fragments from the Middle Stone Age illustrates the earliest-known example of decorated eggs. Their linear depictions signal ownership, as well as the most primitive known examples of social, cultural and cognitive thought. It is the earliest act of creation for a purely aesthetic reason – and it was done 60,000 years ago using a humble egg as the artistic medium.

With a hard, thick shell and polished, ivory-like surface, the ostrich egg lends itself well to carving or cutting, becoming a much-desired *objet d'art* in almost every ancient civilization. Their durability explains the wide distribution of archaeological findings: as perfume containers for the ancient Egyptians, lanterns for the Coptic Christians and tomb offerings for the Punic Phoenicians who believed the egg would provide sustenance to the deceased crossing over to the hereafter.

Howiesons Poort tradition of engraving ostrich eggshell containers dates to
60,000 years ago, excavated from the Diepkloof Rock Shelter, South Africa.
Shards vary in size from 2 to 8 cm (1 to 3 in.).

The history of colour and pigment informs us as to why humans began using food in their creative endeavours. Organic substances needed to paint and create with were the same items that were being eaten. A Palaeolithic human 50,000 years ago saw a bright-purple flower – a crocus – from which three crimson stigmas protruded, reaching for the sky. Pulled and separated from their flower, these tiny red tendrils, once dried in the sun, would become what is now known as saffron. Brewed or macerated, these insignificant threads produce a vivid orange-red that was used in ancient Mesopotamian cave paintings. Later, Buddhist monks adopted the same colour for the saffron dye in their robes. The pigment also produces a pleasing flavour and hue when cooked with rice or other foods.

Throughout art history, many other foods were relied upon in the development of artistic materials until replaced by synthetic chemicals. Starting with early ancient Egyptians in the third century BCE, egg yolk was used as a binder for coloured pigment. Known as tempera paint – from the Italian *temperare*, meaning to dissolve or mix in the right dosage – it gained prevalence in European medieval art. The ancient Greeks were the inventors of encaustic painting which utilized beeswax. The Greek word *enkaustikos* means 'to burn in'. The wax was heated, pigment added and then applied while the mixture was still hot. In the 1500s tempera paint was superseded by oil paint, which used walnut and poppy seed oils blended with other essential oils extracted from coniferous plants such as lavender and rosemary as the drying agent for pigments. Around the time of this early Renaissance, pastels were developed. From the medieval Latin *pastellum*, pastels were derived from a paste that was made from pure powdered pigments such as Armenian bole for reds, azurite for blues and black haematite for dark tones, blended with fig-tree sap, fish glue and sugar syrup, then moulded into workable sticks.

The Golden Age of Food Art in the Renaissance

The Renaissance was a time when cooks and artists vied for the same ingredients or media for their respective crafts. Eggs and lard were binding agents for painters – and it was only in the later fifteenth century when these consumables were replaced with non-digestible vegetable oils. Sugar was a valuable commodity which could only be afforded by the very wealthy and was often moulded to be displayed or served as a status symbol.

The grand banquets and festivals at the royal courts were where the talents of food artisans were able to be flaunted. Feasts were an important tool that helped define social rank and political status. A host made very specific statements to his guests, not only by the food being served (which had to be as lavish as possible), but by the festive table décor known as *schau-essen*, literally 'show food' – elaborate centrepieces made from sugar, butter or vegetables. In Italy, these were known as *trionfi da tavola*, or 'triumphs of the table', and were created in sugar, *marchepane* or even meats and cheeses. The larger and more

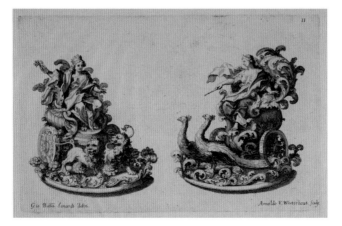

Arnold van Westerhout, *Trionfi of Cybele and Juno – Sugar Sculpture*, c. 1687, etching.

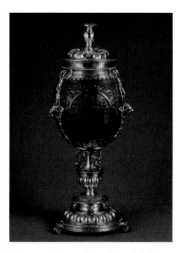

Hans van Amsterdam, *Cup with Cover,*
c. 1533/34, silver gilt and coconut shell.

extravagant the sugar sculpture, the more impressive the host would appear. Popular festivals such as the Italian *Cuccagna* and *Carnevale* showcased entire floats made of food while smaller versions of historical scenes or jokes were sculpted and assembled for court presentation. An ambitious sugar sculpture was created to make a political statement at the 1687 banquet given for Pope Innocent XI, where a 30-metre-long (100-ft) sugar centrepiece depicted allegorical scenes of Aeneas, the mythical hero of the Trojan War.

Culinary examples of *trompe l'œil*, known as 'subtleties', became very fashionable during the Tudor dynasty (1485–1603), when each culinary course was heralded by the entrance of a marzipan cathedral or spun sugar hunting scene. Intended to visually deceive and delight the diners, these culinary masters would construct a spectacularly ostentatious dish such as roasted peacock with its decorative plumage intact, redressed and formed to appear alive – perhaps with its beak soaked with a little camphor and set alight, to give the appearance of breathing fire for added effect.

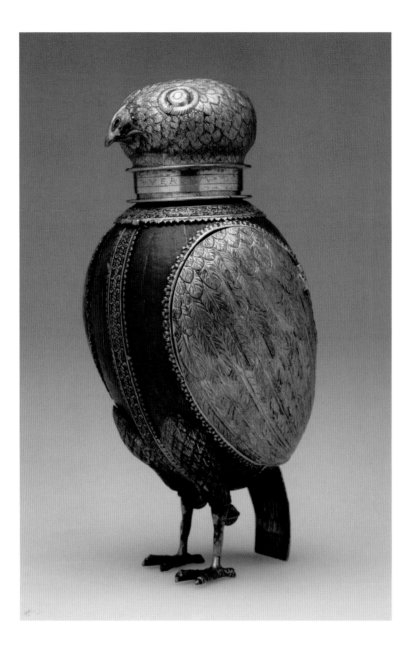

Unknown artist, *Owl Beaker*, 1556, coconut shell and silver with gilding.

The *trompe l'œil* banquet is unexpected and often astonishing. Is what you are looking at truly what you see? Is what you are tasting something entirely different from what it appears to be? There is the visual pun, but also the artist's or chef's intention of transforming the ingredients into a novel creation, distinctive from their origin. For example, a creamy liver pâté was moulded into a sphere, and then glazed to emulate a succulent mandarin orange that looks as though it had just been freshly plucked from the tree, complete with stem. Originally known as Pome Dorres, which means 'Apple of Gold', meat fruit made a spectacular appearance as part of the 1399 cele-bratory feast for Henry IV's coronation. Modern British chef Heston Blumenthal, enthralled with the medieval recipe, serves up a nightly re-creation Meat Fruit in a posh London eatery.

Expanding upon and perhaps surpassing the sugar centrepieces of the Tudors, pageantry of chivalry saw a revival in the form of pastry monuments during the Stuart era. Chef-artists erected large edible castles and staged mock wars for the court of King James I (1566–1625), and these amazed playwright Anthony Brewer so much that he documented the event in 1607:

> Ramparts of pastry crust, and forts of pies
> Entrench'd with dishes full of pastry stuffe
> Hath Gustus made and planted ordinance,
> Strange ordinance, cannons of hollow canes,
> Whose powder's rape seed, charged with turnip shot.

It was only when sugar became affordable to the common man that these *pièces montées* lost their place of importance, and porcelain cen-trepieces became the norm.

Along with sugar, the coconut – known as an 'Indian nut' – was another rare edible prized by European aristocrats that was turned into art. Imported from India and the Americas from the thirteenth

to sixteenth centuries, the milk contained within was thought to be an aphrodisiac and valued as a medicinal restorative. It was believed that poisoned wine would be neutralized by the coconut's shell, which was often richly decorated with gilded silver and semi-precious stones. Fashioned into a hanap (footed chalice) or mazer, wealthy nobles would collect them for their Kunst-und Wunderkammer, or cabinet of curiosities.

Folk Art Traditions in Food Art

Moving from castle to cottage, food art was as prevalent in humble homes as in the royal courts, albeit in less grandiose forms. While royalty were revelling in their extravagantly displayed foodstuffs, the common folk were enjoying their own form of edible embellishments, both groups utilizing the oldest form of sculptural technique:

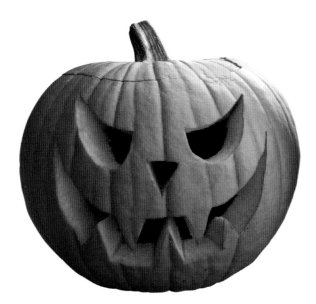

Jack-o'-lantern.

A mid-18th-century antique gingerbread mould, carved in wood.

carving. Gourd carving dates back 10,000 years, probably with a bottle gourd known as a calabash, which archaeologists have found in both East Asia and North and South America. In Peru, *mate burilado* is a 3,500-year-old gourd-carving tradition which still thrives to this day. Eighteenth-century Ireland is where the modern tradition of pumpkin carving got its start. An Irish folktale told of a character named Stingy Jack's dealings with the Devil. Carrying an ember inside a carved turnip, his 'jack o'lantern' lit the way as he wandered the Netherworld. The tradition of carving a turnip, beetroot or swede (rutabaga) on All Hallows' Eve to ward off evil spirits like Jack came to America with the mass immigration of the Irish and Scots to the United States. The prevalence of the New World pumpkin made it the vegetable of choice for the carving of jack-o'-lanterns for families' homes as well as contests such as extreme or underwater pumpkin carving.

Whether in the form of a house or a stylized cookie or biscuit, gingerbread is one of the oldest, most well-travelled foods, with the first known recipe dating back to 2400 BCE Greece. An Armenian monk,

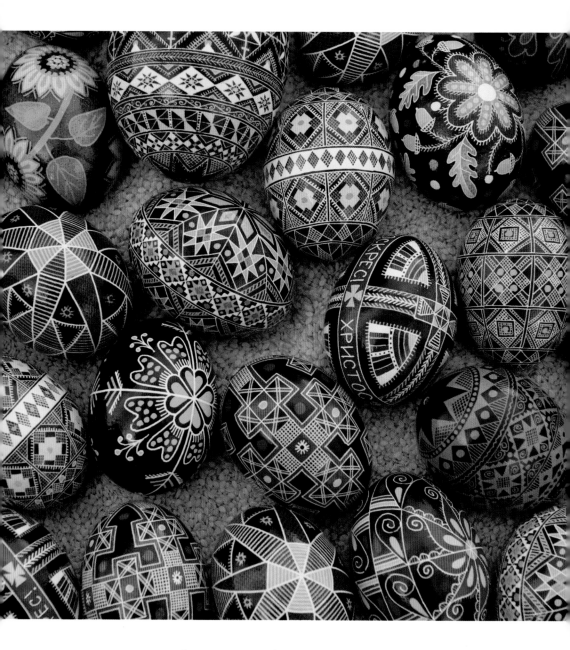

Ukrainian Easter eggs known as *pysanka*.

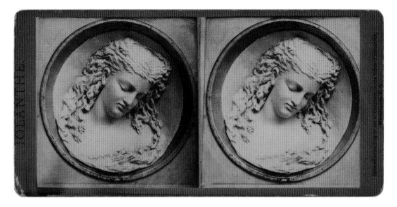

Caroline Shawk Brooks, *Dreaming of Iolanthe*, 1876, photographic print on stereo card of bas-relief butter sculpture.

Gregory of Nicopolis, is reputed to have brought gingerbread to French Christians in 992. In medieval Europe, breadcrumbs were boiled with honey, ginger and a few other spices, and then pressed into a mould. Elaborately and beautifully carved, these moulds were the predecessor to the modern practices of stamping cookies and biscuits and shaping gingerbread into figures of men, animals or hearts.

The decoration of eggs continued to expand from the ancient pagan era, eventually being accepted by many Christian cultures. The most beautiful and elaborate of these come from Eastern Europe, where the process of dyeing eggs evolved with intricate, geometric patterns applied by a *kistka*, a specialized stylus designed to hold and distribute small amounts of melted wax. While the names for the style of folk design applied to the eggs vary from country to country (*pysanky* for the Ukrainians, *marguciai* for the Lithuanians, *kraslice* for the Czechs, and so on), many of the symbols are universally incorporated even though the interpretation and meanings might vary.

America's first state fair was held in New York in 1841 as a way to promote agriculture, livestock and new farming equipment. Now the fairs are fertile grounds for a wide variety of artistic competitions, many

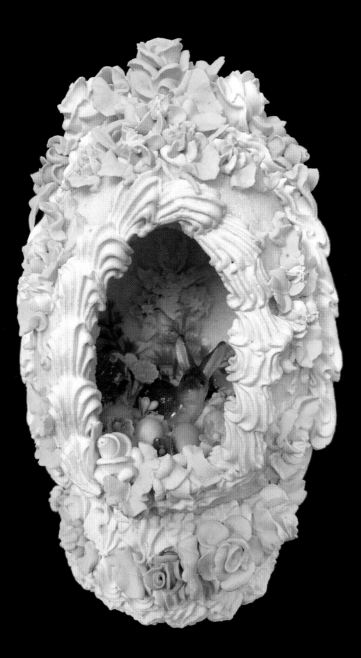

Panoramic Sugar Egg, *c.* 1940, sugar.

involving food, such as 'crop art' mosaics made with seeds, decorated cookies or biscuits on a stick, butter sculpting, or massive, mural-like displays from local granges. Butter sculpting is one of the more popular of the competitions now, but at the turn of the last century, it became a bona-fide profession for its innovator, Caroline Shawk Brooks. In 1867, when her family's cotton crop failed, and most farm women shaped their home-churned butter with moulds, Brooks began sculpting small animals, shells and faces to sell to the local community. She would go on to demonstrate her techniques at large expositions and World's Fairs alongside other professional butter carvers, but it was Brooks who would always be known as 'The Butter Woman'.

Originating in Victorian England, the construction of panoramic sugar eggs became a favoured pastime of American women at the turn of the last century. It was only in the 1930s that the tradition of making them by hand fell away to mass-produced, commercial versions more readily available. The egg shape is made by pressing moist, granular sugar into half-egg moulds and setting them aside to dry. After scooping out the thin, hardened shell, a combination of icing sugar is mixed with a little gelatin to form pastillage. Long-lasting and hard-drying, pastillage is used to assemble the two sides together and is also piped to add decorative elements: flowers, garlands, basket weaves and foliage. Inside the hollow egg, miniature dioramic scenes are staged with tiny porcelain or paper bunnies, chicks or children. Given to friends and family as treasured Easter gifts, the panoramic egg would not be eaten, and the longevity of the ingredients made the gift a family heirloom that is still passed down from generation to generation.

Twentieth-century Art Movements:
From Folk to Formal

At the end of the nineteenth century, the philosophy and paintings of the Impressionists laid waste to the academic and cerebral art establishment, making way for a radical revolution. Out of that upheaval came a dizzying array of artistic expression, including movements that broke imaginative ground with the incorporation of food into their work: the Futurists, Dadaists and Surrealists. Experimenting with new media and techniques, these artists explicitly rejected rationality, logic and reason in favour of new philosophies and hyper-realities: the nonsensical and the absurd.

In their 1921 *Manifesto of Tactilism*, the Futurists established that 'the distinction of the senses is arbitrary.' In 1932, noted Futurist Filippo Tommaso Marinetti effectively channelled the movement's optimistic but ultimately dogmatic philosophies via a cookbook, *La Cucina futurista*. This is arguably the first cookbook ever written by an artist for purely artistic purposes. The volume proposed that some dishes were to be served but not eaten, and only to be experienced by the eyes and nose. There was also to be a complete abandonment of pasta as a food, as Marinetti believed it lacked passion and was too reminiscent of worms. Precursors to the Modernist chefs cooking today, the Futurists unwittingly predicted that scientific equipment would replace traditional kitchen implements.

At the same time that the Futurists were staging their dinner parties, the Surrealists were similarly seeking to de-naturalize the world with their art: making familiar objects alien, while at the same time rendering mundane objects extraordinary. Surrealist Leonora Carrington, whose circle of friends included Man Ray, Marcel Duchamp and Joan Miró, turned up at parties with the soles of her feet painted with English mustard. She deliberately shocked her compatriots by serving her guests omelettes made from their own hair, which she had

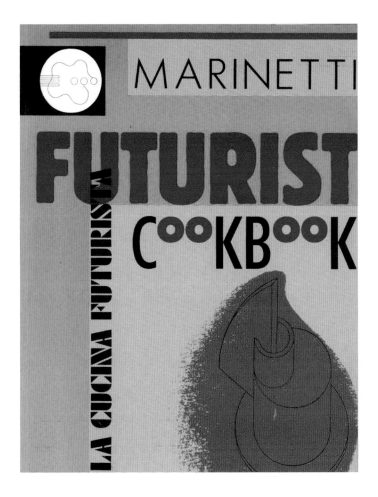

F. T. Marinetti, *The Futurist Cookbook*, orginally published in 1932.

harvested from their sleeping heads the night before. Carrington and Spanish-Mexican artist Remedios Varo spent time concocting absurd recipes; some to invoke specific dreams or erotic notions, and others as culinary practical jokes. Notably, the two preyed upon the Mexican poet and diplomat Octavio Paz by colouring tapioca with black squid ink, serving it as caviar, all the while delighted at the escapade. Famed contemporary chef Michel Richard recreated this as a signature dish with Israeli couscous replacing the tapioca, and offered it up as 'begula' caviar served with lobster and hollandaise.

In Salvador Dalí's *Retrospective Bust of a Woman*, an odd, hairless mannequin is eroticized with the placement of an obviously phallic baguette straddled horizontally across the woman's head, with two ears of corn dangling towards her ample bosom.

This was the era when Picasso was experimenting with his first foray into junk sculptures and Marcel Duchamp was offering a snow shovel or bicycle wheel placed upside down on a stool as 'readymade' art. By simply presenting an ordinary object within an artistic setting, the perspective of what could be considered 'art' was both reimagined by the artist and perceived differently by the public. In a sense, it was *trompe l'œil* at a deeper, more conceptual level.

These artistic endeavours propelled the movement forward with the utilization of everyday items – from junk to food – resulting in a veritable explosion of food-themed artworks. And while the terms 'installation art' and 'performance art' would not enter the artistic vernacular until the 1960s and 1970s, these genres' use of everyday materials owes a great debt to the early Surrealists and Futurists.

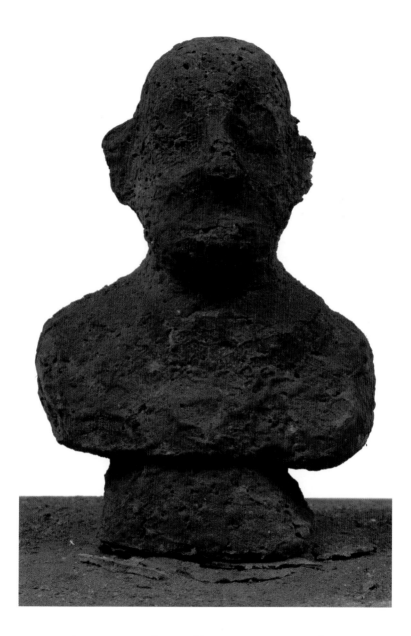

Dieter Roth, *P.O.TH.A.A.VFB (Portrait of the Artist as a Vogelfutterbüste [birdseed bust])*,
1968, chocolate cast with birdseed.

Viennese Actionism and Fluxus

The 1960s was a time of great social upheaval earmarked by riots and protests. Civil resistance fought for racial and gender equality. Students led the counterculture movement with anti-war marches, wide acceptance of sexual experimentation, drug consumption, and an optimism for the future as man landed on the Moon. The anti-establishment philosophies found their way into the art world and helped shaped two critical movements: Viennese Actionism and Fluxus. The former was started in 1960 but was short-lived and transgressive, the Viennese Actionist artists Günter Brus, Otto Müehl and Hermann Nitsch all incorporated food into gruesome performance pieces that oftentimes included animal blood and entrails. Revelling in the grotesque, acts – 'aktions', as the group called them – of butchery and gastronomy were coupled with violent self-mutilation.

Less visceral and transgressional than their Actionism compatriots, the artists of the Fluxus movement were just as revolutionary and ultimately more influential, incorporating similar themes of subversion through visual gags. Founding member George Maciunas and fellow artists Joseph Beuys and Dieter Roth relied on food as a predominant medium in their work. Roth, most notably, expanded on the exploration of foods like meat, fruit, cheese and chocolate with works like *P.O.TH.A.A.VFB (Portrait of the Artist as a Vogelfutterbüste [birdseed bust])*, in which Roth formed a self-portrait bust in chocolate and birdseed with the intention of having the work displayed outdoors, where it would be eaten by birds and squirrels until it disappeared. Roth believed that art 'should change like man himself, grow old, and die', or – in the case of his work made with food – disintegrate.

Through their nihilism and irony, these artists were the progenitors for artists like Marina Abramović who, in her *Rhythm 0* (1974), allowed herself to be the palette upon which the audience could apply (or inflict) any of 72 different objects she had provided – many of them

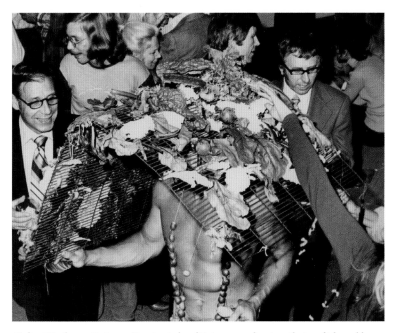

Robert Kushner, *Costumes Constructed and Eaten*, 1972, beetroot hat, radish necklace,
beetroots, Swiss chard, cucumbers, licorice, Cheese Doodles and radishes.

food – upon her body. In November of 1970 Jean Dupuy, a multi-media artist, organized a one-night marathon performance event with thirty other artists: *Soup and Tart*, which began with the serving of soup, bread and wine. Dupuy then 'performed' by preparing apple tartlets before the others in attendance – including budding musical artists Laurie Anderson and Philip Glass – offered up their own musical contributions to the famed evening. Allan Kaprow, a student of Fluxus composer John Cage, coined the phrase 'happenings' as a collection of art-related events to be experienced, such as his 1970 'happening' *Sweet Wall*, which involved building a wall of bread near the Berlin Wall, with jam used as mortar. The American artist Robert Kushner is more famous today for his involvement in the Pattern and Decoration movement, but in the early 1970s he pushed the boundaries with a

performance piece, *Costumes Constructed and Eaten* (1972), in which 'the primary artistic elements would be the ephemeral composition [of the food], the observation of their disintegration through eating, and the lingering sense of gustatory titillation.' As it evolved from a fringe movement towards an accepted staple among mainstream museum programming, performance art gained increased legitimacy within the art community.

Japanese Aesthetics

The philosophy of Japanese visual sensibilities is an essential aspect of this investigation. Principals of grace and subtlety (known as *yūgen*), transitory and furtive beauty (*wabi*) and the concept of *sabi*, an artistic effect that can only occur over the passage of time, are at the core of Japanese aesthetics. In culinary terms, these philosophies present themselves in an overtly elegant fashion in the form of *kaiseki-ryōri*, a multi-course meal epitomized by the delicate, almost magical, balance of taste, texture and appearance. Kaiseki straddles the popular and the formal as it is as much haute cuisine as it is regional craft, providing an ethereal experience like no other.

Because written menus were not commonplace in the 1920s, artisans and candle-makers began the practice of creating *shokuhin sampuru*, or 'food samples', fake models of what was being served in the restaurant. Now commonly seen in every restaurant's street display, hyperrealistic replica food is a growing art form. As the colours fade with time, the original paraffin models have been replaced with long-lasting plastic, which is virtually indestructible.

The surreal aspect of Japanese aesthetics often goes to an eccentric extreme with the adulation of cutesy (*kawaii*) and childish kitsch that overflows into the production of decorative, mass-produced confections (*mochi* and *wagashi*) and character-themed bento box lunches for children known as *kyaraben*. A form of native folk art, *kyaraben* is a

The components of a classic kaiseki meal include an appetizer, sashimi, something simmered, a grilled dish, a steamed course and other dishes at the chef's discretion.

creative expression rooted in the customary lives of ordinary people. With its ancient roots, it is profoundly modern in its use of pop culture motifs utilized to express personal vision, affection and affinity.

The cultural purity of these Japanese philosophies has been wholeheartedly adopted by Modernist chefs with their molecular techniques. The elaborate plating requires minute attention to detail as well as an understanding of how ingredients will complement one another. The defined and ordered set of principles and aesthetics together provide an enticing balance of flavours, textures and visual design.

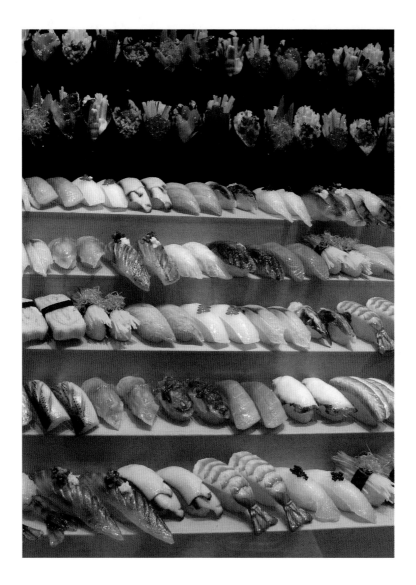

Sushi in Osaka, Japan. Department stores across Japan sell hyperrealistic plastic sushi.

The Twenty-first Century

With the rise of social media, there is unprecedented access to new ideas and images, especially in the genre of food art. Taking pictures of one's meal has become ubiquitous to the point where some chefs now prohibit food photography or have policies against bright flashes. These diners want to share their experience virtually, knowing that their friends' and followers' other senses can be stimulated via their images.

When I created *That Over Which We Have No Control*, I consciously played upon the sense of visual anticipation. The essence of receiving a gift is alluded to with the classic Tiffany Blue Box. Jewellery is expected, yet here the 14-karat gold rings are not set with diamonds or precious gems, but with representations of desserts and sweets set among real edible chocolates. The viewer is challenged to grasp the

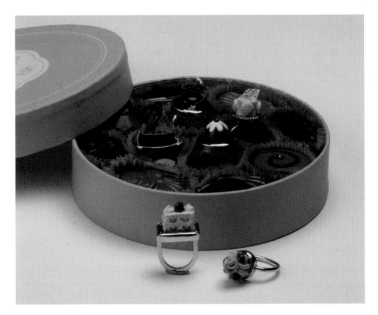

Carolyn Tillie, *That Over Which We Have No Control*, 2009, 14k gold, chocolate, Japanese gumball machine toys.

irony of gold as a luxurious and valued commodity against the transitory materials of plastic and chocolate – and to go a step further and wonder if the artwork in question smells or tastes like what it appears to be composed of.

This is a provocative game I hope you will start to play as you thumb through the pages of this abecedarian book and see the offerings that artists, chefs and craftspeople have created from such ingredients as chocolate and cheese, bread and butter, or gingerbread and gelatin. This book is not envisioned to be eaten as a single-seating, 26-course meal, but to be browsed through as a series of bite-sized morsels. Pick an entry that suits your taste at the moment and take a nibble. If you are feeling sated, take a break before the next repast. And although the book is structured in an A to Z format, there's no reason not to skip around as your appetite dictates. Or if you're famished for a full artistic banquet, feel free to indulge to your heart's content!

Apple to Zucchini

A

is for Apple

Folksy and engaging, the delightful effigies known as Skookum dolls are indigenous to North America, as the first patent for their design was filed by Montana homemaker Mary McAboy in 1913. The heads are fashioned from a hand-carved apple that shrinks and dries into a wizened face. Bodies are composed of wood, blanket fragments, leaves, straw and grass stuffed in a muslin sack. Marketing to a tourist trade, McAboy partnered with H. H. Tammen Co. of Denver, Colorado, in 1920 to keep up with the demand. Sadly, once mass-production took hold, the designs were mostly changed to resemble Native American peoples and by the 1940s were not even made of apples anymore.

Leslie Griffin, *Apple Head Dolls*, 2017.

A

is for Avocado

As a seven-year-old living in a small town in Italy, Daniele Barresi's imagination came alive, inspiration struck, and he started carving food. Now, twenty years later and living in Australia, when he touches his knife, his 'mind gives up to the heart and transmits directly to the hands. It is like magic.' With a will to sublimity, this avocado demonstrates an internal beauty that can only be realized by an artist. There is some debate as to fruit and vegetable carving's origins. Some believe it began over seven hundred years ago in Thailand when Nang Nopphamat, consort of the thirteenth-century Sukhothai king Sri Indraditya, carved a flower and a bird into a vegetable for the Lunar New Year celebration known as *Loi Krathong*. Specialized fruit and vegetable carving blossomed the world over in the 1980s, with manuals, classes and artists such as Barresi making names for themselves in this practised and detailed art form. Designs range from intricate to whimsical, from stylized to anthropomorphic, and from elegant to extravagant.

Daniele Baressi, *Avocado*, 2017.

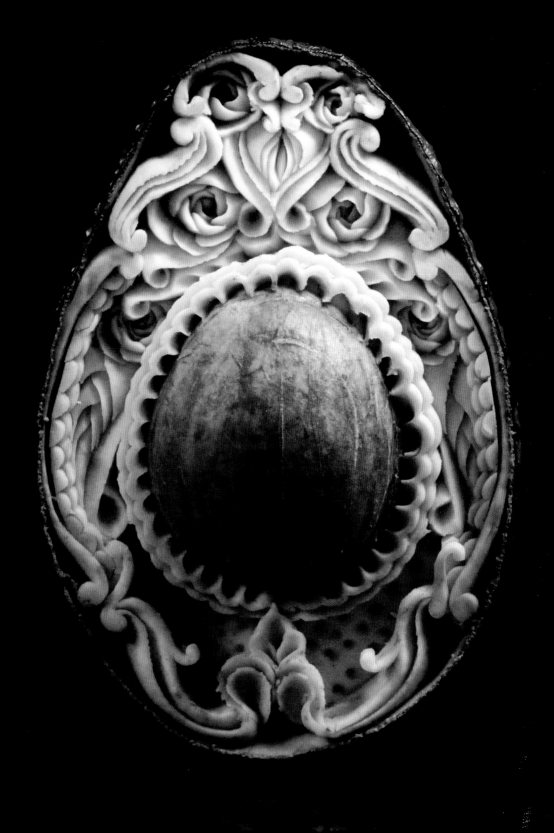

B

is for Bread

From the Middle Ages through to the modern era, bread has been a mainstay of most diets and that singular foodstuff utilized by peasants and gentry alike in the creation of speciality loaves with decorative designs. Bread, more than any other food, becomes important in its ritual use, especially in the Slavic countries, where elaborate loaves are formed into very specific shapes are adorned with symbolic patterns thematically representative of major life events. At a christening, the godparents are given two knot-shaped loaves to honour their role in protecting the child. Christmas bread has images of sheep or wine casks, depending on the occupation of the master of the house. In the Eastern European countries of Bulgaria, Russia, the Ukraine, Romania and Poland, breads prepared for weddings, known as *korovai*, are abundantly festooned with spirals, rosettes or doves to symbolize good luck and blessings.

For Chef Ciril Hitz, who teaches baking and pastry-making, bread is a favoured medium. As a child, he made salt dough ornaments for

A collection of decorative breads in Berlin, Germany.

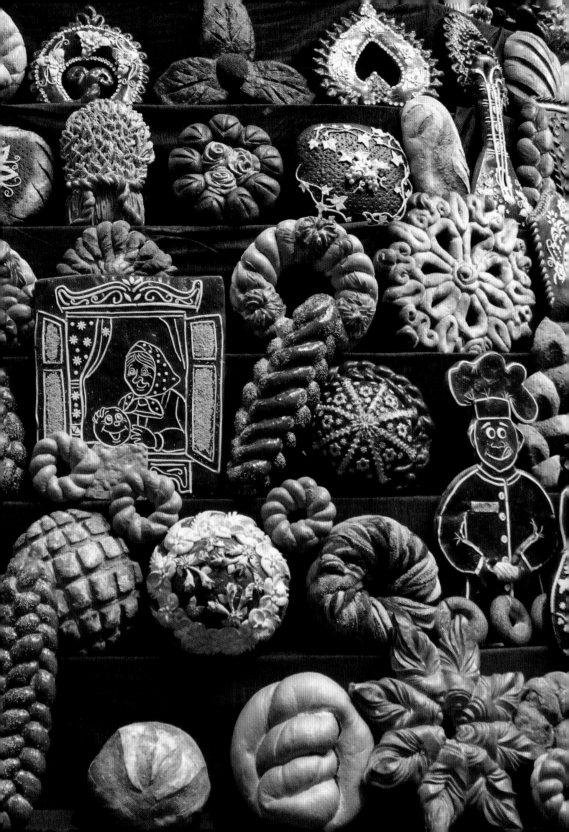

Ciril Hitz, *Bread Showpiece*, 2010.

Detail of a bread showpiece by Ciril Hitz in which the striations of colour can clearly be seen.

Ukrainian wedding bread known as *korovai*.

Christmas, but now competes in the Coupe du Monde de la Boulangerie – the Olympics of baking competitions – where showpiece creations have to be completed in under eight hours. One of his skills is the ability to incorporate colour into his work using natural ingredients such as spinach, beetroot, turmeric and cocoa. Hitz's bread uses mostly buckwheat and light rye flours, and maintaining colour can be difficult as it can disappear in the baking process. While the rules dictate that the competition pieces must be edible, most are shellacked to preserve them for at least a few weeks before they eventually begin to decay.

Rachel Shimpock is a trained metalsmith who teaches classical jewellery techniques. She has also stylized herself as a 'Kitchensmith' with a desire to bring the comfort of food and the wistfulness of personal memories into her work. By electroforming and powder-coating actual food – in this case slices of bread – she is able to preserve and embellish it. Shimpock emphasizes texture, colour and surface treatment, in the unity between the adoration of personal ornamentation and consumables. A jewel-encrusted bread bangle distils formal elements of classical adornment with the sensual encounter of comfort food on the body.

The smell of bread slices being coaxed into toast is both comforting and nostalgic. London-based artist and food historian Tasha Marks cashes in on those evocative sentiments with her performance piece *The Poetry of Toast*. Within a gallery setting, she invites participants to explore the creative process of making toast while revelling in the reminiscent powers the olfactory sensations invoke as the smell wafts throughout the gallery. After printing poetry on their hot-buttered toast with a laser-cut stencil and a little cinnamon, the guests are invited to consume their own creations, ingesting their own art, taking an everyday ritual and transforming it into an artistic process.

Rachel Shimpock, *Bread bracelets*, 2015, bread, electroformed copper, silver, enamel, citrines.

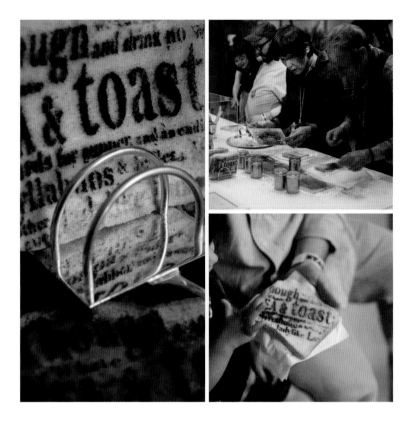

Tasha Marks, *The Poetry of Toast*, 2015, bread, cinnamon and cocoa.

B

is for Butter

Artists have been carving and sculpting food into creative shapes since ancient times. In 1536 Bartolomeo Scappi, Pope Pius V's cook, is reputed to have prepared and served a nine-course feast composed entirely of carved foods – including elaborate butter sculptures. Among his imaginative butter animals was a camel being driven by a Moor, a lion being wrestled by Hercules and an elephant decked out in a howdah carriage.

The queen of all butter sculptures is the life-size cow created by artists at the Iowa State Fair. The tradition began back in 1911, when J. K. Daniels carved the first butter cow to promote local dairy products. Since then, each sculpture has been crafted by a native Iowan assigned to the task – often with sculptors training their successors. Today the sculptures are created by Sarah Pratt, who is only the fifth butter sculptor since the tradition began over a century ago. Starting with a metal and wood frame, she artfully fashions over 272 kilograms (600 lb) of low-moisture, pure-cream Iowa butter into the fabled bovine shape.

Sarah Pratt, *Cow*, 2016, butter.

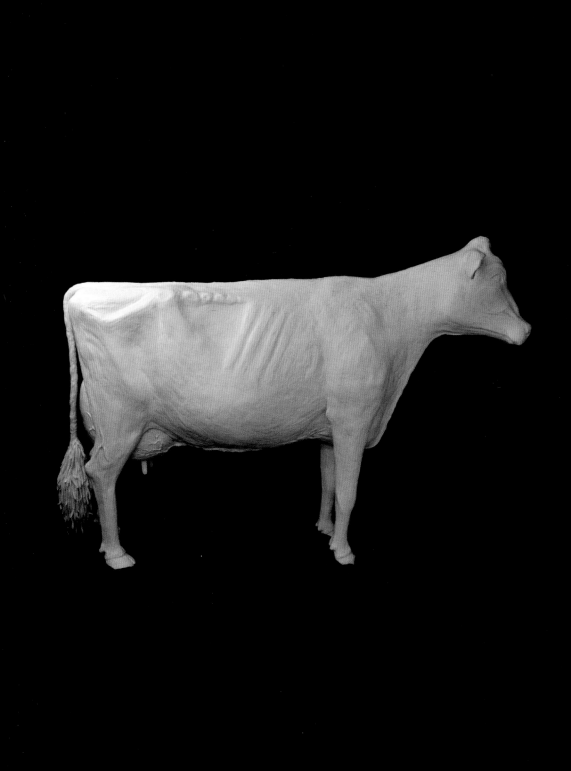

The art of butter sculpting has long played a venerable role in Tibetan Buddhist culture, in which the carved creations are known as *tormas*. Presented as offerings to the Buddha, they are crafted from local yak butter, sometimes with barley flour (*tsampa*) that is enriched with colourful dyes. The ornate figures are typically carved into conical shapes, and decorated with *kargyen* (white ornaments) in the shape of a disc to emulate the Moon, Sun or lotus flowers. Tormas continue to be sculpted in various forms for display in shrines and monasteries, as well as for use in sacred rituals. They are often consumed after being broken apart into small pieces, and a few remnants are always left behind for the gods themselves.

Unknown Tibetan monks, *tormas*, 2014, yak butter.

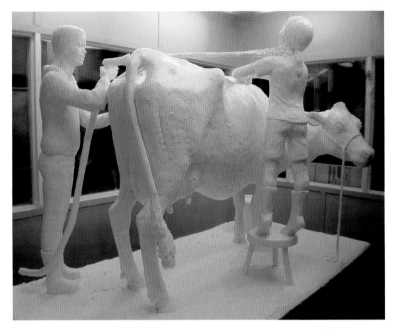

Jim Victor and Marie Pelton, *Cowgirls Just Wanna Have Fun*, 2014, butter.

Jim Victor didn't start out creating with food at all. Having gradu-
ated from the Pennsylvania Academy of Fine Arts in 1968 as a sculptor,
his work was originally bronze, steel or stone. In the mid-1980s, a local
chocolatier commissioned Victor to create chocolate busts of actors
Mickey Rooney and Ann Miller to commemorate their Broadway pro-
duction of *Sugar Babies*. A decade after that, the Pennsylvania Farm
Show advertised for a butter sculptor, which expanded his métier,
and soon Jim would meet and marry Marie Pelton, a fellow sculpture
graduate from the same university. Together they have constructed
a speciality refrigerated mobile booth, able to travel and display their
skills in not only butter, but cheese, chocolate, fruits and vegetables.

C

is for Cake

The rise of novelty cake art has escalated considerably in the past decade, with the assistance of social media and television shows such as *The Great British Bake Off*, *Ace of Cakes* and *Cake Boss*. There is no limit to the subject-matter that can be constructed in cake but, regardless of how extraordinary a cake looks, at the end of the day it still has to taste good and fresh, so the timing of the cakes' assembly and artistry is always last-minute. Decorative elements are manifested in frosting, chocolate or fondant, a sugar paste that has the ability to be rolled very thinly and moulded around a carved cake shape. It is then hand-painted to realize the details. Like many cake artists, Atlanta-based Karen Portaleo obtained an art degree before she took up baking cakes. Preferring modelling chocolate over frosting or fondant, she sculpts and forms her delectable designs with the same type of wooden tools she learned to use as a clay artist.

Karen Portaleo demonstrates the artistry of constructing
a hyperrealistic goblin cake.

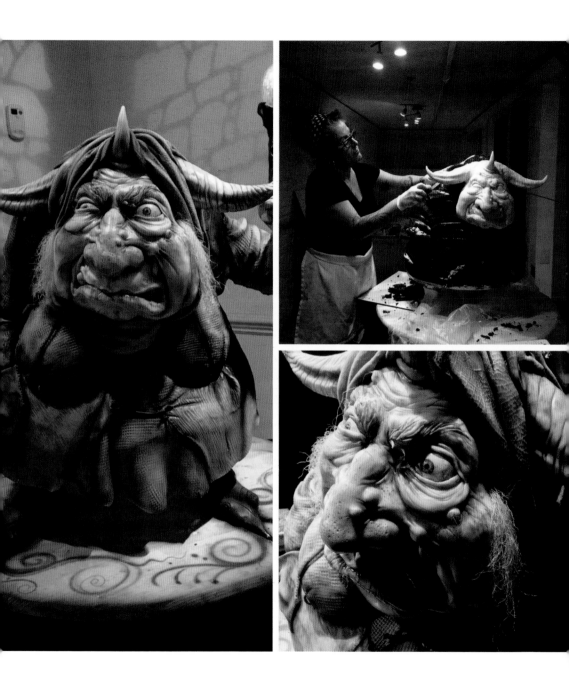

C

is for Caviar

The high-definition image of Frankenstein's monster, as portrayed by well-known Hollywood icon Boris Karloff, harks to the classic, black-and-white film era and is certainly not a surprise to the viewer except that the brooding gaze in the picture is created entirely out of caviar. Brazilian artist Vik Muniz, one of the most celebrated living artists today, is well known for the creation of masterpieces in all manner of edible materials from chocolate syrup to sugar, from peanut butter to jam. Considering himself a photographer, Muniz cites his upbringing under a climate of South American political distress as a driving force in devising new ways to communicate. Delighting in the subversion of a viewer's expectation, Muniz manages to generate a seemingly tactile texture with the food, before taking the photograph of the creation and then demolishing the artwork forever. The seriousness of his subject-matter is often offset with the very materials from which they are made. For Muniz, his intent is not about misleading the viewer with a perfect illusion, but about giving a measure of their own belief in wanting to be fooled.

Vik Muniz, *Frankenstein*, 2004, caviar. This is part of an entire series of caviar monsters, including Dracula and The Mummy.

C

is for Cheese

There is nothing cheesy about the skill and craftsmanship of sculptor Sarah Kaufman. Known as 'The Cheese Lady' and a Guinness World Record holder, Kaufman is in demand the world over for her stunning representations – all in cheese. In celebration of the fortieth anniversary of the landing on the Moon, a life-sized astronaut was created for the Neil Armstrong Air and Space Museum in Ohio. To begin, three 290-kilogram (640-lb) blocks of Wisconsin cheddar cheese were stacked one atop the other. Ultimately, weighing over 860 kilograms (1,900 lb) – not counting the 13.6-kilogram (30-lb) Baby Swiss moon, lovingly cradled in the astronaut's arm – the almost 2-metre-tall (6-ft), flag-holding icon took the artist over 150 hours to create.

Sarah Kaufman, *Astronaut*, 2009, cheddar and Swiss cheeses.

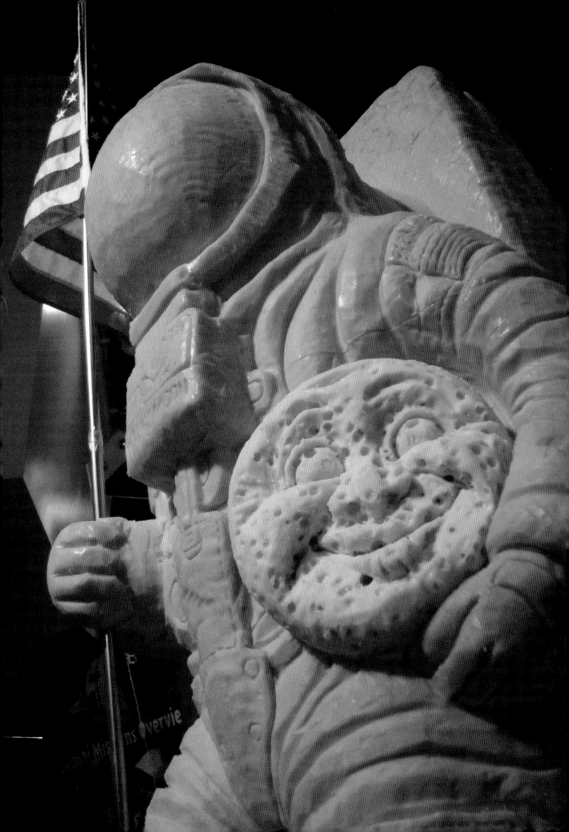

C

is for Chocolate

Chocolate is an astonishing medium for the food artist. It can be melted and cast into a shape like a bronze statute or chiselled and sculpted like a block of marble. Chocolate can come in a variety of hues and is easily malleable. It produces heady, intoxicating aromas and, along with bread and sugar, is one of the ingredients used in international competitions for showpiece presentations. For Austrian-born Gerhard Petzl, it is a medium that he has explored in all its avenues, from the scientific, in growing chocolate crystals as an organic art form, to performance art where he paints tribal tattoo designs on living models. Believing anything can be made of chocolate, he proved it with the creation of an entire Baroque table setting for a festival in Hong Kong. The project weighed approximately 250 kilograms (550 lb) and consisted of over 2,500 individual pieces to create the plates, napkins, glasses, cutlery, centrepieces, cakes and fruit.

Ed Ruscha was following on the heels of Viennese Actionist artists when he first installed *Chocolate Room* at the Venice Biennale in 1970. For the artist, it was a beginning foray into unusual and organic materials such as cherry juice, Heinz baked beans and Metrecal, a 1960s diet

Gerhard Petzl, *Baroque Chocolate Table*, 2013. Detail of chocolate fruit plate.

Gerhard Petzl, *Baroque Chocolate Table*, 2013.

Ed Ruscha, *Chocolate Room*, 1970 and 2015, chocolate-coated paper.

beverage. Restaged at the Museum of Contemporary Art in Los Angeles in 2005, *Chocolate Room* was a singular experience that challenged the viewer's eyes as well as the sense of smell. In total, 360 sheets of paper were impregnated with chocolate with a silkscreen technique and then hung vertically like the shingles of a gingerbread house. People who entered the room were fully engulfed in a potent aroma that often overwhelmed. The matte, velvety look to the sheets of paper depicted the artist's sense of humour as he looked for unexpected results in the experimentation of transforming popular items in modern culture with traditional techniques.

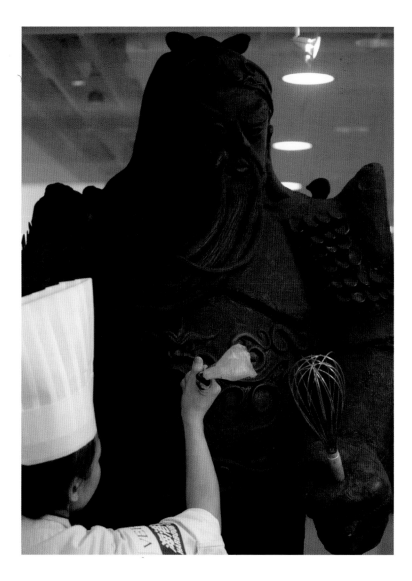

A chef works on a 2-m-high sculpture of Guan Yu made from chocolate for the Hong Kong *A−Z Chocolate Art Exhibition* in 2010.

C

is for Cocktail

For performance, installation and pastry artist Leah Rosenberg, 'C' not only stands for cocktail, but for colour. It is a rare visual artist who so deftly bridges the gastronomic world, as Rosenberg presents interactive installations which explore the connections between food, colour and one's own expectations. In a multidisciplinary offering, as a recent artist-in-resident, she explored the new city with its diverse colour palette. Translating those representational hues into a gallery setting, she welcomes participants into the newly painted space with prepared cocktails which mirror and complement the very colours she discovered. As the weeks of the residency progressed, so did the expanding colour spectrum of visual and culinary offerings.

Leah Rosenberg, *Color for the People*, 2017, assorted beverages. Performance at the McColl Center, Charlotte, North Carolina, USA.

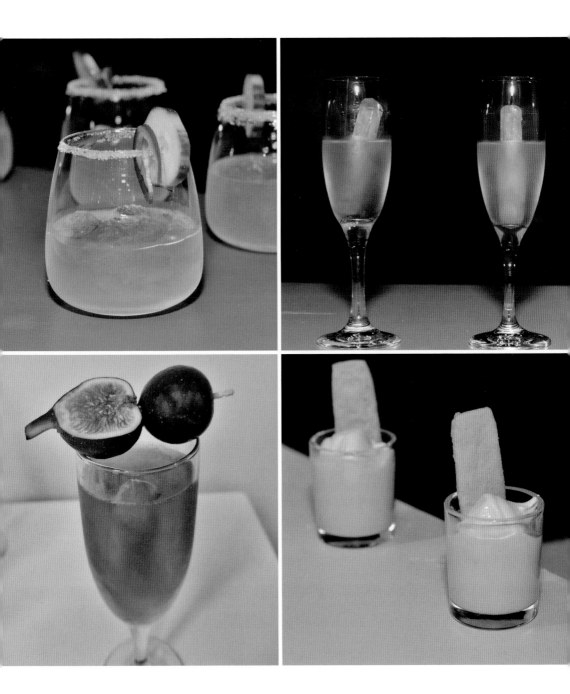

C

is for Coffee

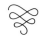

Historically, coffeehouses provided patrons with a place to debate the issues of the day over a freshly brewed cup of coffee. Today, Ghidaq al-Nizar creates powerful images that echo those profound communal ideals. Working as a barista in his native Indonesia, al-Nizar sees coffee as more than a beverage. It is his chosen medium in the creation of delicate and often heartfelt paintings depicting the tragedies of war in the city of Aleppo, Syria. His visual dialogue manifests an allegorical treatment that starts with a thumb or handprint, enhanced by varying hues – from the palest tan to inky black – obtained from nothing more than the leftovers of the artist's morning brew. There is a rich and beautiful irony expressed by ethereal strokes of coffee emanating from the fine point of a tiny paintbrush, producing unforgettable images of loss, death, sadness and destruction.

Lucia Matzger doesn't even drink coffee any more, but its organic powers continue to energize and inspire her. Transforming what would otherwise have been discarded kitchen scraps into intriguing artworks,

Ghidaq al-Nizar, *Tiger's Day*, 2016, coffee on paper.

Lucia Matzger, *Kimono,* 2015, coffee-stained filters.

Matzger arranges stained coffee filters to create patterns that evoke a conversation among the shapes, angles and lines found everywhere from the natural world to classical and modern architecture. The graceful, repetitive designs are reminiscent of swirling wood grains, conveying a serene essence and primal calm. Harking back to the Buddhist view of the world as a place of transience, the power implied by coffee's abilities to awaken body and mind becomes the potent symbol in an ephemeral symbol of transformation.

In 1823 the steamboat *Maysville*, carrying a shipment of coffee, travelled from New Orleans, up the Mississippi River, to St Louis, Missouri. Founded by French fur traders barely fifty years prior, the city boasted a strong affinity towards its French ancestry, especially in its love of coffee. By the turn of the twentieth century, St Louis would become the largest inland distributor of coffee, turning the city's obsession with the inky brew into a thriving, essential industry. *Coffee: The World in Your Cup & St Louis in Your Cup* was an exhibit staged by the Missouri History Museum in 2015. For the entrance, a giant mural of the city's skyline with its famous Gateway Arch, measuring 48 metres (160 ft) long and over 2.5 metres (8 ft) high, was created by fifty staff members and volunteers from over a quarter-of-a-million coffee beans.

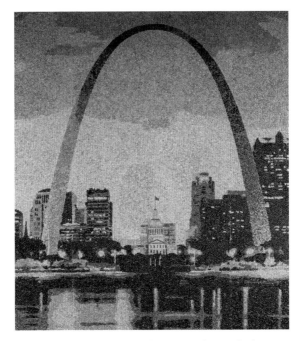

Missouri History Museum employees, members and volunteers,
St Louis Arch (detail), 2015, coffee beans.

C

is for Corn

As European settlers travelled to inhabit the Americas, corn was incorporated into their folk art. Every part of the corn was utilized in ways that range from the culinary to the utilitarian. Dried cornhusks became soft when soaked in water and were braided into dolls and baskets. An American general, Douglas MacArthur, was reputed to have designed his own corncob pipe. During the 1880s in the Midwest of North America, entire castles built out of corncobs became a fashionable and competitive phenomenon.

In the late nineteenth century, handfuls of Great Plains cities erected these cathedrals of grain for mostly promotional purposes. The primary goal was to entice industrialists and new settlers to populate their growing hamlets, but also to celebrate a burgeoning agricultural enterprise. The only example of this botanical art that still stands, but continues to evolve, is the grand Moorish Revival temple constructed for the Corn Belt Exposition of 1892 in Mitchell, South Dakota. Nearly every year, the external murals are changed with themes dictating the designs, from 1969's Space Age topic to the 2008 honouring of

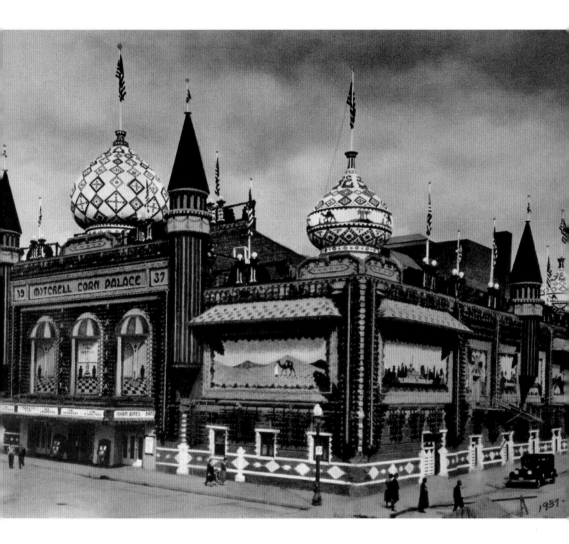

Mitchell Corn Palace, 1937, South Dakota.

Detail of a mosaic at Mitchell Corn Palace.

Everyday Heroes. Working in thirteen different shades of corn along with other locally sourced grains and native grasses, talented artists keep local history and crop art vibrant and alive.

Mitchell Corn Palace in South Dakota.

D

is for Daikon

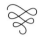

The art of fruit and vegetable carving dates back more than 1,400 years. Some believe the craft originated in Thailand in the 1300s, while others believe its roots lie in Japan's Tang dynasty (618–906 CE). Japanese chef Takehiro Kishimoto, whose online moniker is 'Guku', is famous the world over as a true master of the craft known as *mukimono*, in which the daikon radish, and other fruits and vegetables, is a favoured decorative medium for decorative garnishes. Grown primarily in and highly valued by chefs in Southeast and East Asia, the daikon radish is milder than its bitter, red cousin. Often measuring over 30 centimetres (12 in.) in length, the pristine, white, firm flesh lends itself particularly well to being dyed as well as to holding whatever shapes and designs the artist creates.

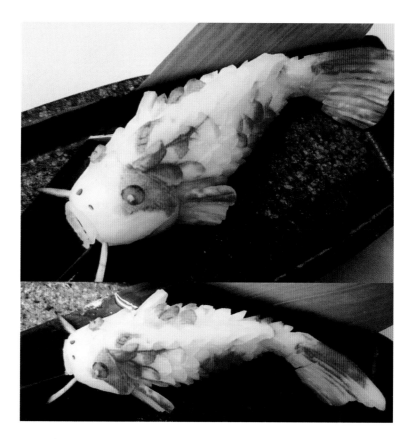

Takehiro Kishimoto, *Koi*, 2017, daikon radish.

E

is for Egg

As a child, Theresa Somerset was mesmerized by images in *National Geographic* magazine of elaborately decorated Ukrainian *pysanky*. Encouraging her daughter's interest, Somerset's mother bought her a *pysanky* kit from a Ukrainian friend, but it would be several decades before the artist opened the gift. Tenacious and stubborn, Somerset experimented with the *kistka*, an ancient tool used to draw fine lines with melted beeswax through a small, heated funnel directly onto the egg. By teaching herself this technique, she fully realized her artistic potential. Now a member of the International Egg Art Guild and World Egg Artists Association, she teaches the ancient craft of applying the wax resist to the eggs and dyeing them vibrant colours. Merging this folkloric technique with etching the eggshell to produce a bas-relief sculpture, Somerset creates elegantly modern designs.

Egg-ceptional artist Gil Batle spent twenty years of his life incarcerated in five different prisons for fraud and forgery. While in prison, Batle used his artistic skills in tattoo design and greeting cards to

Theresa Somerset, *Ostrich Egg #2*, 2017, acid-etched egg.

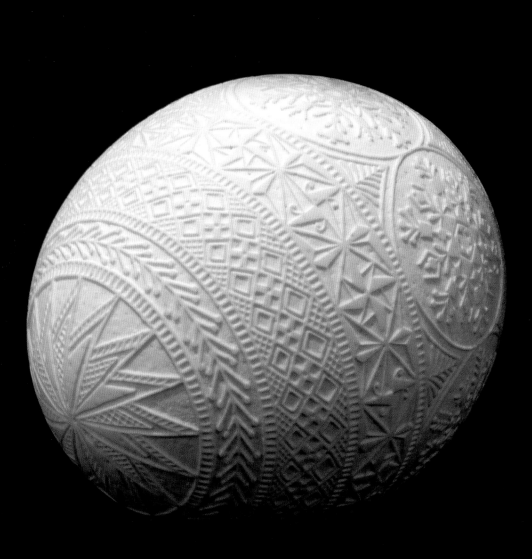

barter with fellow inmates. His design talent actually helped him survive the brutal setting and protected him from gang violence. After he was freed, part of his healing and rehabilitation into a new life meant redirecting his talent into the surprising medium of ostrich eggs. Employing a little-used technique of carving into the eggs, his series *Hatched in Prison* and *Re-Formed* chronicle his journey and help exorcise the demons of his incarceration, translating the disturbing stories of prison life – from race riots to stabbings, from suicides to cavity searches – into surprisingly beautiful sculptures. Pristine in their elegant ivory hue, the natural eggshells provide a delicate dichotomy in their juxtaposition of the fragile symbolism of birth and life with ominous depictions of chains, cages, violence and death. Batle has brought the viewer into his violent past and has literally carved out a future of hope and success.

Gil Batle, *Bully*, 2017, bas-relief carved ostrich egg.

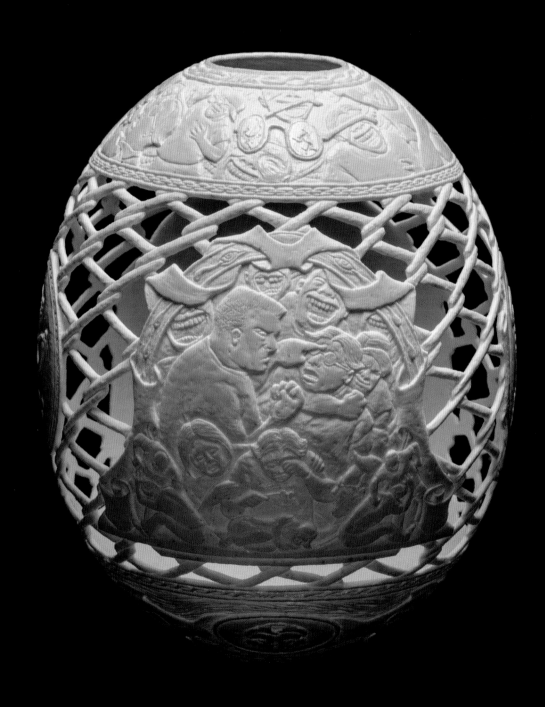

F

is for Fruit

❧

In American grade schools, many students are taught how to construct an electrochemical battery with a potato. Expanding on that childhood science project, artist Caleb Charland was inspired to create an entire body of work. *Back to Light* is a series of photographs in which fruits and vegetables are used to spark the imagination and illuminate the global concern of the earth's energy resources. In *Fruit Battery Still-life*, Charland manifests a quiet sense of nostalgia with golden tones and warm shadows. A classic still-life is a celebration of man-made and natural objects and is often an ephemeral warning of the brevity of human existence. Traditionally the image of decaying fruit is a metaphor for man's mortality where the fresh food is depicted as offering sustenance to the human body by providing light and warmth. By utilizing organic materials, the artist invokes nutrients and energy to express an endless cycle of regeneration.

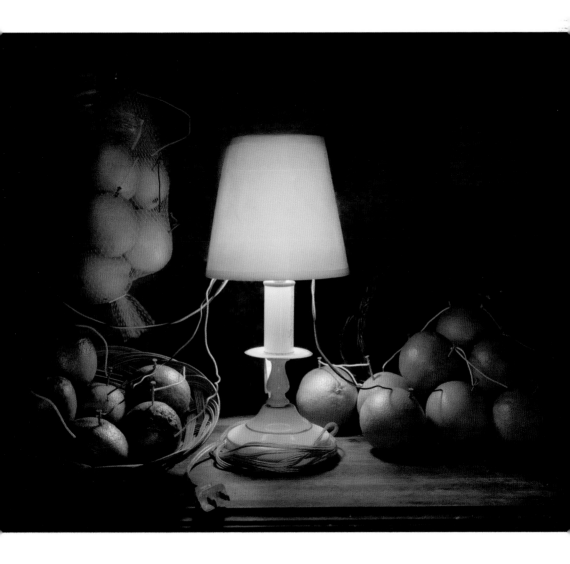

Caleb Charland, *Fruit Battery Still-life (Citrus)*, 2012, photograph.

G

is for Gelatin

In Mexico, these brightly coloured, impossibly perfect flowers limpidly floating in half-domes of crystal clear gelatin are known as *gelatina*. Shimmering and jewel-like, these three-dimensional, spiky red chrysanthemums, purple roses and engaging yellow sunflowers were a metaphor for life to their Mezoamerican forebears.

A fruit-flavoured confection, *gelatina* is prominent on the dessert menus of family gatherings, as well as more formal occasions such as *quinceañeras*, the coming-of-age parties for fifteen-year-old Latin American girls. This mid-century staple of United States households is now an obsession south of the border, where gelatin is reputed to be consumed daily in nearly 90 per cent of Mexican homes.

In Vietnam, similar jelly cake desserts are known as *thạch rau câu,* the 'thạch' literally translating to agar-agar, a natural vegetable gelatin. Expanding to many neighbouring countries, the growing demand is driving a thriving cottage industry, especially for women. Working from the bottom of crystal clear, pre-set domes or cake rounds, artists

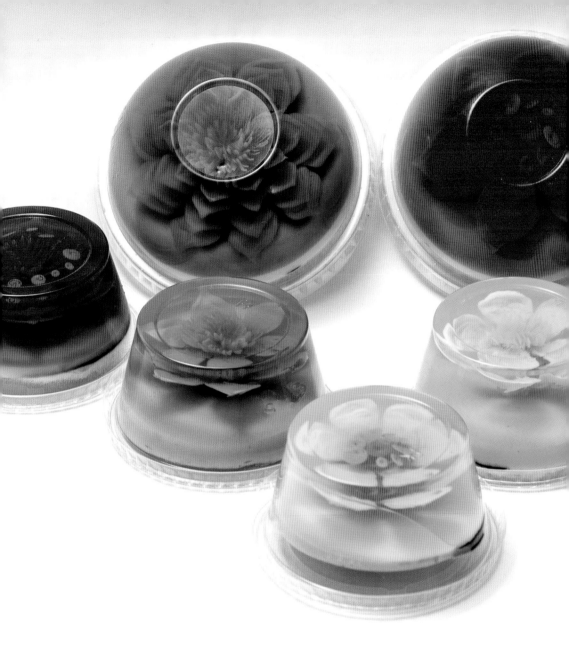

Unknown Mexican artists, miniature *gelatinas*, 2017, gelatin.

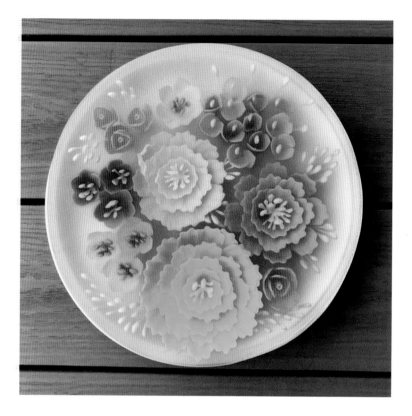

Giselle Wang/Wishing Upon A Cake, *3-D Flower Cake*, 2017, gelatin.

manipulate speciality tools, nozzles filled with coloured liquid jelly, and hypodermic needles, deftly creating and injecting curved petals, straight stigma or a bulbous stamen, the delicacy of which are only fully realized when the artist flips over the creation to reveal the three-dimensional garden.

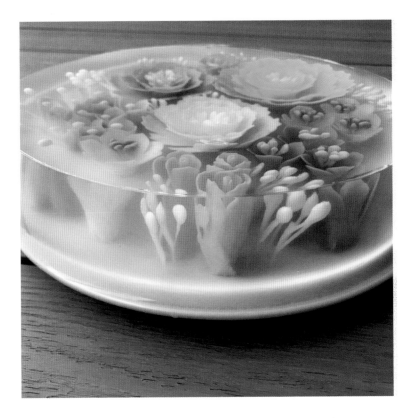

Giselle Wang/Wishing Upon A Cake, *3-D Flower Cake*, 2017, gelatin.

G

is for Gingerbread

Recipes for gingerbread have been chronicled back to the 900s, but the popularity of gingerbread soared in the early 1800s when German siblings Jacob and Wilhelm Grimm wrote a fairy tale, *Hansel and Gretel*. The tale tells of two starving children who stumble upon an edible house in the forest and, through their ingenuity and guile, escape the clutches of a cannibalistic witch who used the edible abode a lure. The story was so popular that German bakers began creating miniature gingerbread houses which have since become a worldwide Christmas tradition. Boutique hotels all over the world offer life-size gingerbread houses for patrons to walk through, or to inspire us all in our own miniature creations.

Opposite top: Life-size gingerbread house, from Disneyland Hotel, California.

Opposite below: Families the world over like to recreate their own homes in gingerbread, but few can measure up to the sweet tradition of White House chefs in their majestic representation of the Executive Mansion as shown here from 2017.

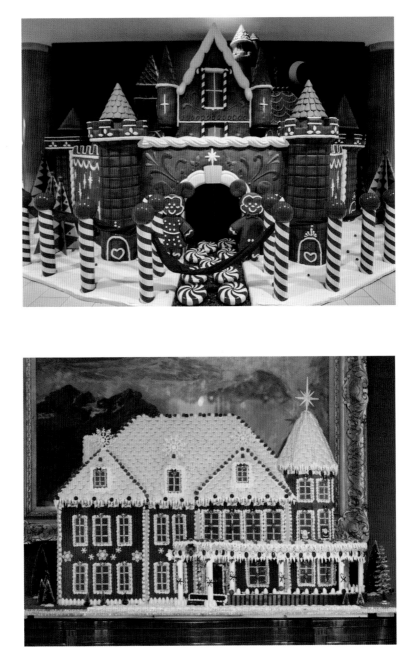

G

is for Gummy Bear

Many of us are kids at heart who love to play with our food – and how can you not play with an adorable little teddy bear? Peruvian-born artist Dicapria wants to tap into people's imagination and encourage them to play by creating spiritual mandalas and pyramids using Gummy Bears. Combining stained glass with the illumination of the colourful, translucent gummy bear creatures, she combines lighthearted ascendancy with Buddhist and Hindu subconscious symbolism. Dicapria presents us with an otherworldly fantasy as her clean, geometric lines invoke an alchemical mysticism, while the sweet rainbow of luminous bears engages our inner child with their playful, mischievous personas.

Dicapria, *Gummy Bear Pyramid*, 2016, Gummy Bears.

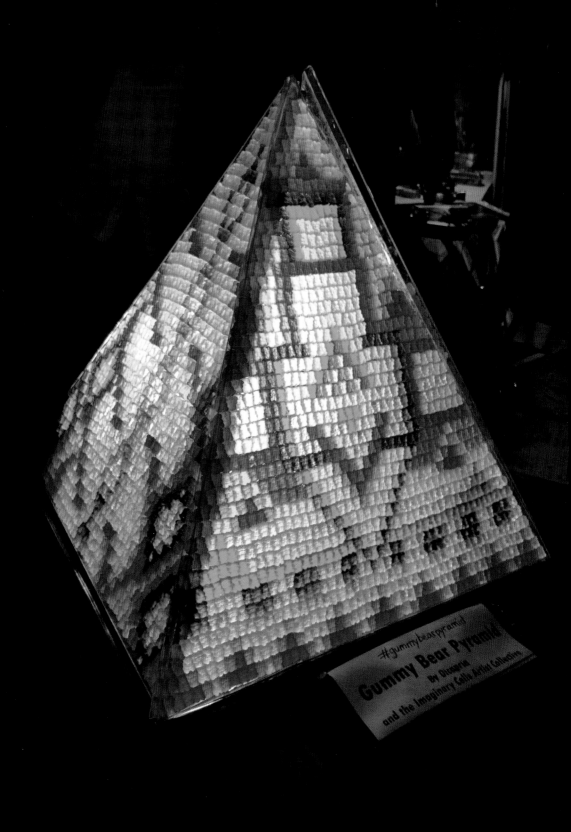

Gummy Bear Pyramid
#gummybearpyramid
By Disopia
and the Imaginary Celtic Artist Collective

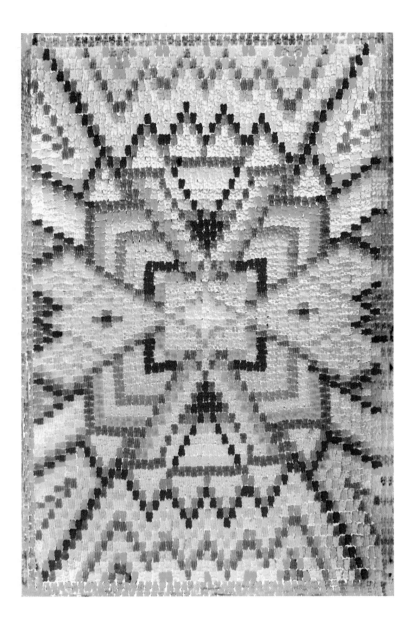

Dicapria, *Gummy Bear Mandala*, 2015, Gummy Bears.

Gummy Bear detail.

H

is for Honey

There is something about honey that makes it inexplicably luxurious. Perhaps it is the golden hue which gives photographer Blake Little's models a Midas appearance by being engulfed in the amber liquid. *Preservation* is the name of the series in which Little enrobes his figures in the unctuous ooze. Evoking the fossilized tree resin that entraps pre-historic animals and plants, the translucence of the honey seductively preserves and intensifies the manifestation of absolute quality. The viewer is beguiled, simultaneously repulsed and compelled, conjecturing the sensations as captured in the single moment the camera shutter clicked its image.

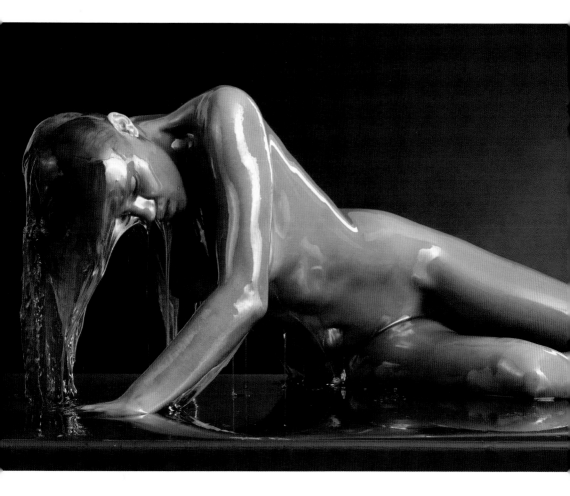

Blake Little, *Chandra, Reclining*, 2012, honey on human, photograph.

I

is for Icing

Icing is usually used to decorate cakes or cookies. The Canadian artist Shelley Miller uses icing to create opulent murals on walls, reminiscent of fragile blue-and-white Delftware porcelain. With no classical culinary training, she mastered piping and painting techniques that take professional pastry chefs years to achieve. Like many installation art pieces, the work is intended to be temporary, and the eventual erosion is a natural part of its inevitable demise. The blue, azulejo-style of the sailing ship harks back to the imagery of the slave ships in the fifteenth and sixteenth centuries, when global sugar production exploded. This history and the beauty of Miller's creations, as well as the decay and disintegration, are themes that run through Miller's work; she wants the images to slowly vanish the same way memories fade.

Shelley Miller, *Stained*, 2011, handmade sugar tiles, hand-painted design with edible inks. Applied to exterior wall with royal icing. Additional piped icing surrounding tiles. Ephemeral installation, lasting nine weeks total. Produced during a one-month residency at Open Space, Victoria, British Columbia.

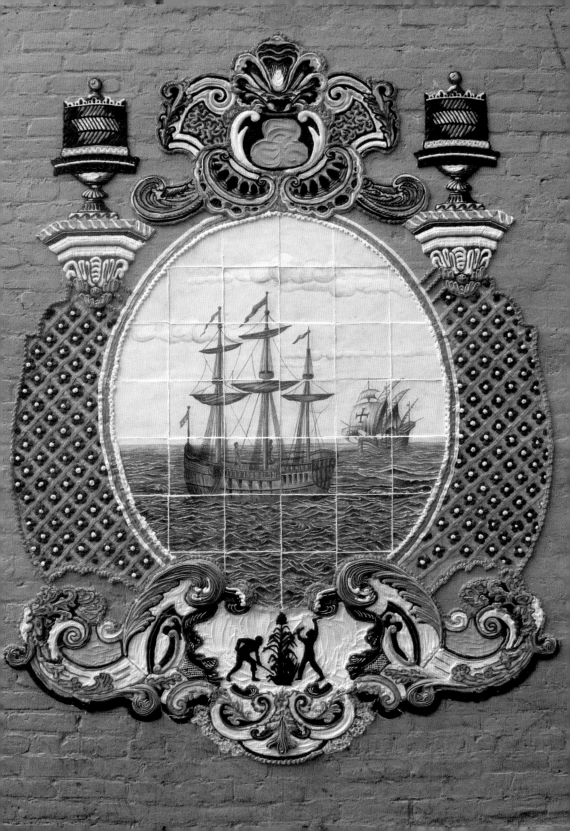

J

is for Jell-O

Generations of children have been inspired to build innovative creations with Lego bricks. Today, Romanian-born artist and chef Rares Craiut reinvents these iconic toys as culinary works of art, crafting the blocks from Jell-O® infused with colours and flavours derived from medicinal plants. When Craiut was a child suffering from food shortages in communist Eastern Europe, his grandfather taught him how to forage nutritional plants for tea and jam. All the while, the young Craiut imagined the kinds of toys being played with by his Western counterparts. Now as an adult living in Brussels, he develops participatory performance art replete with associations of childhood pleasures, curiosities and food memories. Among the most notable is the *Childhood He Never Had*, a dinner that includes an edible representation of the very toy he was entirely unfamiliar with as a child, which now beguiles him as an adult.

Rares Craiut, *Childhood He Never Had*, 2015, Jell-O®.

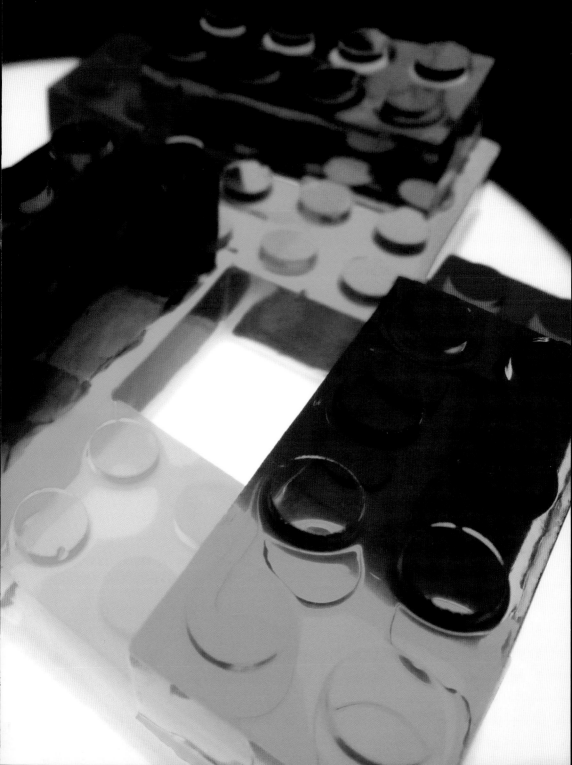

K

is for *Kyaraben*

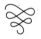

Most people are familiar with Japanese bento boxes as fully balanced, Japanese meals, but giggle when a familiar face or charming animal formed from rice or seaweed stares back at the unsuspecting diner. *Kyara* means 'character' and *kyaraben* started off as well-balanced and nutritious lunches, made by homemakers for their elementary or primary school children. Parents get their children to eat all of their vegetables and protein by creating cute and engaging characters – not to play with, but to attract the children by the food itself. Competitions are now held to illustrate the skill of creating playful scenes of cartoon or anime characters, animals or plants as a delectable meal.

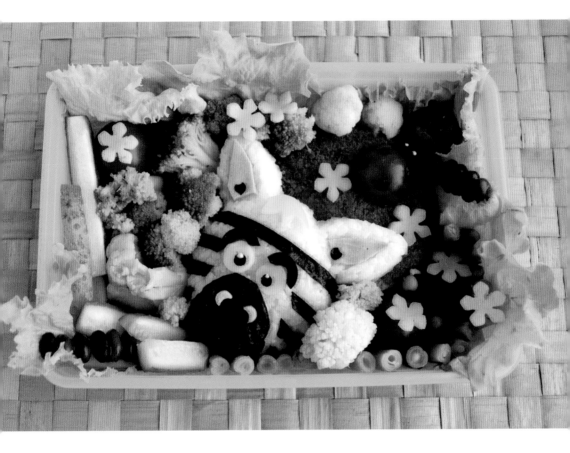

This playful zebra is made of rice, complete with black nori stripes. It is surrounded by vegetables cut into flowers and deliciously playful tomato ladybirds.

L

is for Latte

Baristas all over the world take pride in pouring steamed milk into shots of espresso to conjure the perfect decorative heart rosette or fern leaf. Competitions typically feature two categories: free pouring, in which the pattern is created during the pour, and etching in which a tool is used to create the pattern. Few baristas have taken their chosen craft to the extreme of Singaporean artist Daphne Tan, who has elevated the latte into a playful form of sculptural art. After attending a workshop on the appreciation of gourmet coffee, Tan started researching three-dimensional latte art. Experimenting with methods to stabilize the foam, she will vault her creations out of the cup, down the sides and occasionally embellish them with carob powder or food colouring, expertly applied with a simple bamboo skewer.

From humble beginnings, Diana 'Dee' Milashevskaya has emerged as a master of latte art. She loved to draw as a child in Moscow and enrolled in a design institute when, while working at a coffee stand, she discovered latte art. After apprenticing with a two-time Russian

Daphne Tan, *Octopus*, 2017, foamed and decorated milk over espresso.

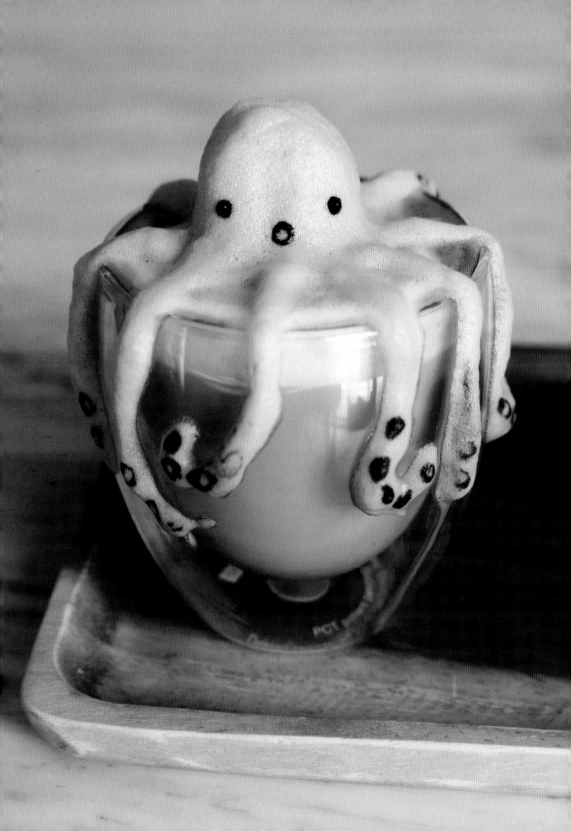

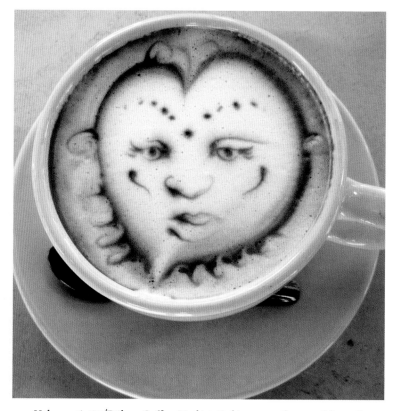

Unknown Artist/Dubsea Coffee, *Machiato Etching*, 2010, decorated foamed
milk over espresso.

champion, Milashevskaya entered her first competition in Moscow as
a novice and emerged in the top five with a chance to move on to the
World Championship. Her work has attracted keen attention as she
has embraced her vocation as a coffee artist, now training others in
boutique coffee preparation and offering master classes on drawing
on coffee with pigments. Dee's goal is to inform the world that coffee is
not just a beverage, but offers both taste and beauty; latte art is an art to
be embraced.

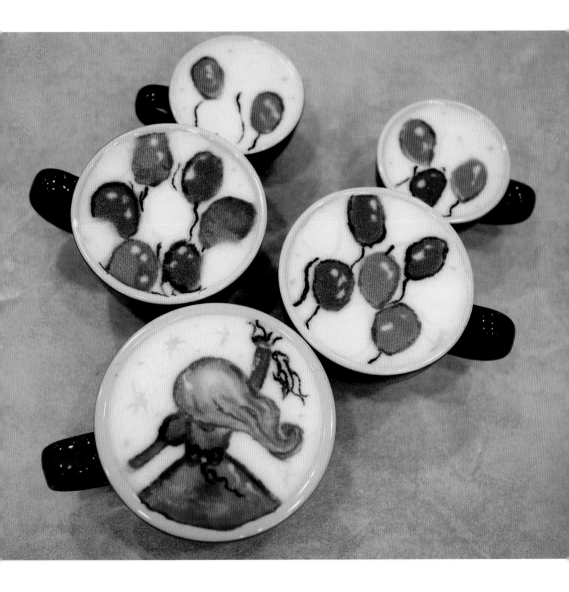

Diana Alexeevna Milashevskaya, *Towards Dreams*, 2018.

L

is for Lobster

❦

Lobsters became an obsession of Surrealist artist Salvador Dalí in 1936 when he created the famous *Lobster Telephone*. Writing a memoir, *The Secret Life*, he lamented that when ordering a grilled lobster in a restaurant, he wondered why a boiled telephone was not served instead. The great World's Fair of 1939 was staged in New York City and Dalí was invited to create a pavilion, the likes of which had never been seen before and may never be seen again. The resulting *Dream of Venus* was one part amusement ride and two parts Surrealist installation art, combined with a sprinkling of female nudity and a dash of absurdity. Tickets to enter the pavilion of pulchritude were purchased from a fish-head-shaped kiosk before entering the oceanic fun house where partially clad, 'living liquid ladies' swam through giant tanks filled with fanciful creatures. True to the Surrealist philosophies of unlocking images that would explore the unconscious worlds of sexuality, desire and violence, an 11-metre (36-ft) bed was covered with flowers where a reclining Venus would sleep, surrounded by lobsters being grilled on hot coals.

George Platt Lynes, *Salvador Dalí*, 1939, gelatin silver print with applied pigment.

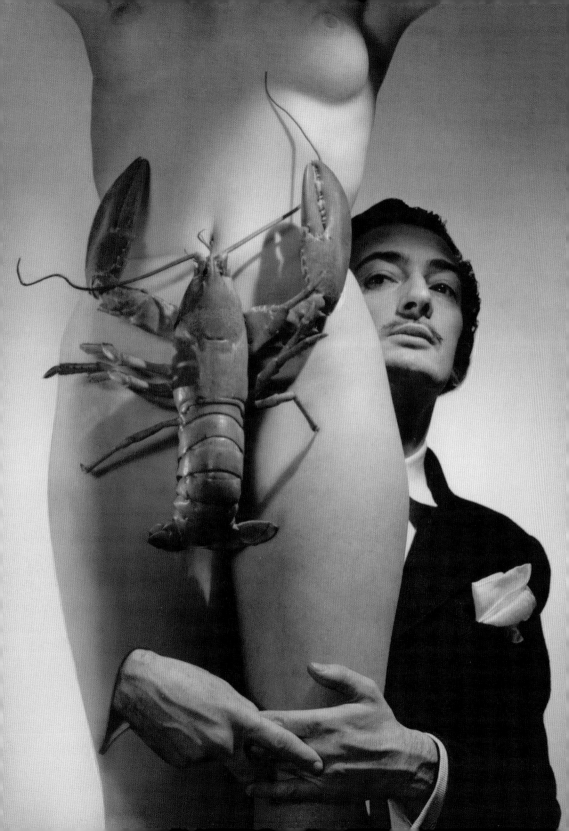

M

is for Marzipan

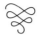

Marzipan is a wide-travelled dough made from a finely ground flour of almonds, sweetened with a little honey or sugar. One of the oldest confections still being created today, it probably originated in ancient Iran, but some believe it came to Persia by way of China. It was easily transported back to Europe by Crusaders in the twelfth century, as its simple ingredients would last during long journeys. The Arab legacy influenced monastic traditions, as fourteenth-century nuns of the Martorana convent in Sicily shaped the almond paste into colourful fruit shapes. Now known as *frutta martorana*, even though the convent no longer exists, the fame of the harvest-themed confections lives on and thrives. In Northern and Central Europe, the most auspicious New Year's gift is that of the 'lucky pig', or *Glücksschwein*, fashioned from pink marzipan.

Marzipan creations from around the world, 2017, almond paste: (from top left) Barcelona; cherries from Lombardy; Duke John of Sweden emblems from Sweden; fruit-shaped marzipan from Florence; marzipan pig from Germany; pears from Italy.

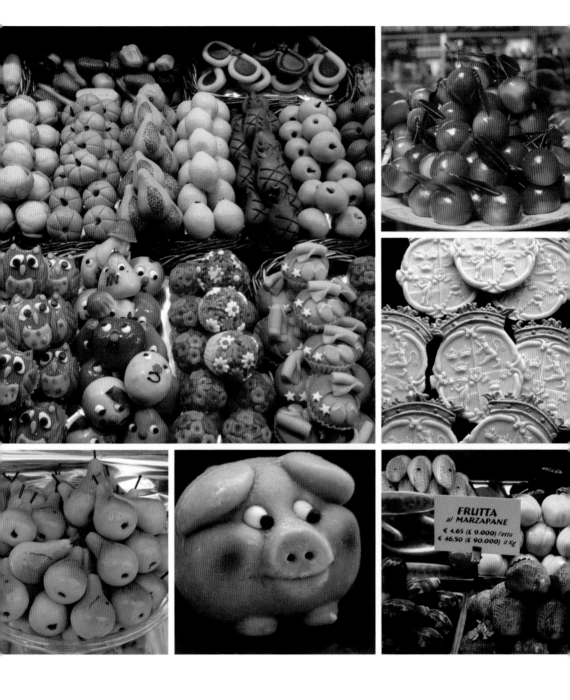

N

is for Noodle

❧

Noodles are made from flour, eggs and salt. A simple dough, it can be rolled out, cut, extruded and coloured and is an easy medium for all sorts of artistic endeavours. Seattle pasta powerhouse Linda Miller Nicholson noodles are turned into everything from fashion statement to fine art. Incorporating plant-based ingredients such as harissa for orange, turmeric for yellow and a combination of beetroots and blueberries for a true purple, a full spectacular spectrum of colours is obtainable to be shaped and moulded into doughy concoctions of whimsical shapes and designs.

Singapore-based Indonesian artist Cynthia Delaney Suwito relies on mass-produced instant noodles in the enactment of her performance piece *Knitting Noodles*. Believing that daily, menial tasks are the result of complicated city systems, she seeks to demonstrate that the food one consumes is an attempt to ease the burdens and tasks of life. Methodically knitting the ubiquitous Chinese noodles, Suwito invites the viewers to meditate upon their own daily activities; to see them from this different perspective.

Linda Miller Nicholson, *Starry Night*, 2016, semolina noodles.

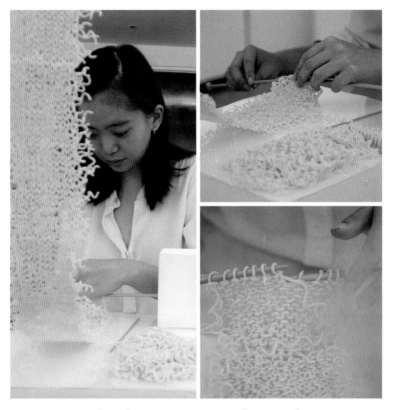

Cynthia Delaney Suwito, *Knitting Noodles*, 2014, video.

California artist Carlo Marcucci creates elegant, modernist sculptures that are geometric in form and rectilinear in composition. Surprisingly, the striations of coloured patterns embellishing the form have been created with long, thin lines of dried spaghetti. Individually and meticulously glued – one spaghetti noodle at a time – onto carefully constructed wood frames, an ordered sense elegance is achieved. There is an irony in how fragile, dried pasta so easily shatters as an ingredient compared with the implication of strength and solidity in the form as it seemingly breaks apart and embraces the negative space.

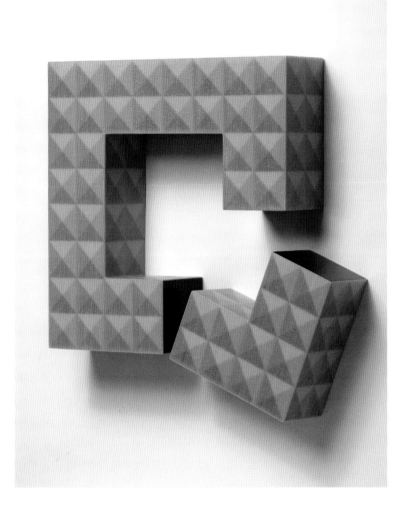

Carlo Marcucci, *Wheatfields LXVI*, 2007, spaghetti and squid ink spaghetti on painted wood.

O

is for Oreo

❦

With a playful stroke of ingenuity that gives new meaning to the phrase 'smart cookie', artist Judith Klausner creates a sweet riff on the silhouette cameo. Traditionally a bas-relief carved into a stone, the classic cameo depicts scenes or figures. The word 'cameo' might derive from the Arabic word *khamea*, which means amulet. Klausner's cameos take on additional layers of iconography by showcasing portraits delicately shaped in the marble-white frosting of Oreo cookies. Much of her artistry speaks to the interconnectedness of femininity and its association with crafts. Klausner offers a new, cultural perspective as transmuted by modern mundanity – as in this simple cookie – with tasks traditionally perceived as women's work; that of the relentless and demanding chores of homemaking, crafts and meal preparation.

Judith Klausner, *Oreo #14*, 2011.

P

is for Pastry

For pastry chef and instructor Lauren Haas, three critical factors come into play in the creation of a dessert: aesthetics, taste and the practicality of the dessert's construction. Who is not immediately drawn to a bakery window with its perfect cylinders of pink raspberry mousse next to sturdy triangles of sliced lemon tarts sitting behind the mirrored glacé domes of chocolate bombes? The pastry chef at first entices with the look of their creation, be it the shimmering, immaculate glaze, the flutes of piped frosting, or the sliver of a fruit garnish that tantalizes with a hint of what is hidden within. Flawless execution is pointless if the flavours don't deliver. More than mere artists, magicians such as Haas must take into consideration the elements of architecture and structural design to ensure the creation is physically feasible while appearing technically perfect. A balanced design will factor in complementing textures of streusel with sponge, a caramel with compote or ganache with gateaux. After transcending expressions of line, colour, texture and form, the lasting remembrance is the most important quality: taste.

Lauren V. Haas for PreGel America, KYSS, 2017, cassis, cherry, almond and Zéphyr white chocolate.

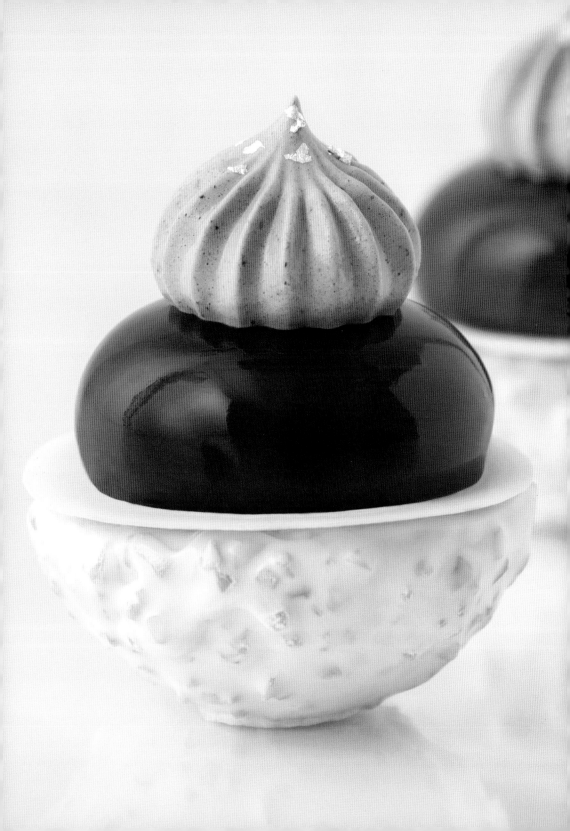

Lauren Haas for Cacao Barry, *Memphis*, cross section, 2017.

Lauren Haas for Cacao Barry, *Memphis*, 2017, pecan sponge, coffee bourbon whipped ganache, dark caramel mousse, sea salt caramel glaze and a buttery, crispy pecan praline base.

P

is for Pumpkin

Carving his own niche in the competitive and creative world of pumpkin decorating is 'Farmer Mike' Valladao. Wearing signature orange overalls, grasping chisels and a buck knife, and tackling pumpkins that can weigh 45 kilograms (100 lb) or more, Valladao sculpts more than he carves. Manifesting expressions of gnarled teeth, furrowed brows and glaring eyes in the pale orange flesh is no small feat, but it is masterfully palpable. The creation of humorous, grotesque or frightening pumpkin carving originated with the custom of the jack-o'-lantern from the folklore of eastern England. For All Hallow's Eve, or Samhain, on 31 October and All Saints' Day (1 November), turnips and *mangelwurzels* were first used to create the faces of goblins or spirits and were representative of Christian souls trapped in purgatory. Some believe their homes will be protected against those spirits wandering the earth with the placement of a jack-o'-lantern on their doorstep. The rise of the pumpkin for such duties manifested in colonial America and makes a spectacular appearance in Washington's Irving's 1820 short story 'The Legend of Sleepy Hollow', which depicted a headless horseman with a carved pumpkin standing in for the severed head.

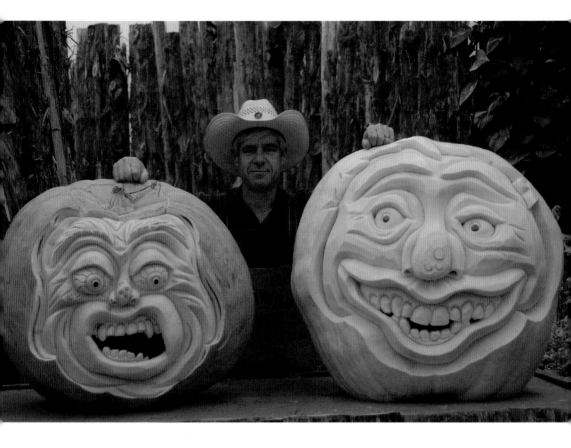

Mike Valladao, Halloween pumpkins, 2016.

Q

is for Quail Egg

Looking at these delicate trinket boxes, one might believe them to be the original, jewel-encrusted, precious metal eggs given as gifts by tsars Alexander III and Nicholas II. The original instruction given to the world-renowned jeweller Peter Carl Fabergé in 1885 was that the Easter egg surprise should open and contain a gift. These miniature quail egg offerings are just as impressive as the Imperial eggs they emulate. Fashioned from very fragile, shatterable quail eggs, the ornately bedecked boxes measure barely one-tenth of the size of their metal counterparts.

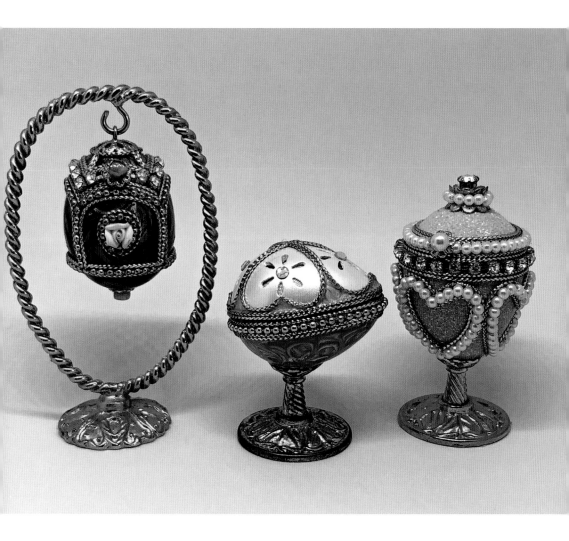

Kingspoint Designs, *Trinket Boxes*, *c.* 2000, quail eggs.

R

is for Radish

Noche de los rábanos – or Night of the Radishes – dates back to the 1500s, when the Spanish introduced radishes to Mexico. Legend states that in the mid-1800s a particular crop of radishes was so plentiful that a portion of the fields was forgotten and by the time the overlooked radishes were harvested, their peculiar sizes and shapes were brought to the Christmas market as oddities. The sellers of the colossal produce, hoping to entice those heading to the *zócolo* (town square) for services, carved fanciful designs into the bright, ruby flesh. The event became an official celebration in 1897 when the mayor, Francisco Vasconcelos, declared 23 December the official Night of the Radishes. Often grown oversized to accommodate the artisans' creativity, full scenes are presented that may depict the Nativity, Maya imagery, local animals such as alligators and snakes, or architectural motifs.

Unknown artists, *Noche de Rábanos*, *c*. 2014, carved radishes, Oaxaca, Mexico.

R

is for Rice

A tiny grain of rice is the perfect medium for crop art. Planted in a field, rice plants collectively can produce art on a massive scale. As an individual grain, rice can be sculpted or drawn upon. In Aomori, a small Japanese prefecture, there is a town, Inakadate, where rice has been growing for more than 2,000 years. The villagers, wanting to honour that tradition and generate some tourism, used the very fields as their canvas. In 1993 more than 1,200 people from the community planted four different types of heirloom rice that, when fully grown, would create an image. Other towns in Japan followed suit, and *tanbo* – or rice paddy – art became a growing phenomenon, with hundreds of thousands of people visiting when the dramatic images begin to appear. Due to the complicated perspective of the designs, observation towers with raised platforms are constructed to offer the best heightened viewing angle.

From the macrocosmic fields to the microcosmic grain, rice itself is considered lucky in many cultures, so it is no surprise to find rice being used in its singular form in the creation of artwork. Living by the motto 'Little things mean a lot', British artist Willard Wigan is the world's

Unknown artists, *Tanbo*, 2010, crop art in rice, Inakadate, Japan.

Unknown artists, *Tanbo*, 2010, crop art in rice, Inakadate, Japan.

foremost micro-miniature artist. Sharpening the ends of needles into blades, Wigan carves rice, coffee beans and sugar crystals. Utilizing a meditative technique to slow down his entire nervous system, Wigan only works in infinitesimal movements, in between the beating pulses of his heartbeat. The precision and tolerance needed to produce such delicate work can only be seen through a microscope, and many of his creations are deliberately placed on the heads of pins or in the eyes of needles, to put them in perspective.

Unknown artists, *Tanbo*, 2010, crop art in rice, Inakadate, Japan.

Willard Wigan, *9 Camels in the Eye of a Needle*, 2009, rice.

S

is for Salt

The world's single largest example of food art occurred organically, over several centuries, and is now a UNESCO World Heritage Site. The Wieliczka and Bochnia salt mines in Poland were established in the thirteenth century, producing table salt until their closures in 2007. Working miners started a tradition of carving sculptures as tributes to the legions of fellow workers who died under the harsh conditions. Starting in 1895 and continuing for the next sixty years, chapels were constructed in the salty caverns and soon one of the largest and most spectacular sacred spaces was created. The largest room for worship is known as the St Kinga Cathedral, austere in its grey stillness and covered with bas-relief scenes and religious statues inspired by the Bible. As rich and imposing as unpolished granite, the rock-salt carvings include everything from a grand altar and sparkling chandeliers to an intricate reproduction of Leonardo da Vinci's *Last Supper.*

Unknown artists, Leonardo da Vinci's *Last Supper*, *c*. 1895, carved as a bas-relief
in salt, Wieliczka Salt Mine, Poland.

Overleaf: Unknown artists, *St Kinga Cathedral*, *c*. 1895, Wieliczka Salt Mine, Poland.

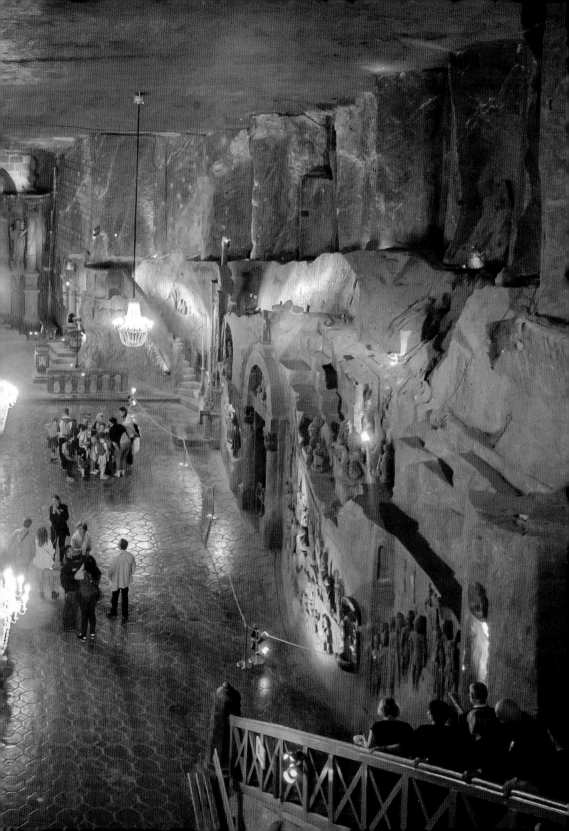

S

is for Seed

Mosaics made with seeds are a classic form of crop art and utilize techniques similar to pointillism in painting or needlepoint in textiles. In 1965 the Minnesota State Fair established a new competition in the hobby craft category for 'crop art and arrangements', sponsored by the Division of Farm Crops in the Agriculture-Horticulture Building as a way to teach the city folk about the importance of seeds and farm crops to the state's economy. Lillian Colton, a local beauty shop owner and amateur oil painter, heard about the competition and entered a year later with a simple picture of two cows on a hill with a tree. Winning her first First Prize, from then on Colton was heralded as the Seed Queen, retiring from competition in the early 1980s so that 'others would have a chance at winning ribbons'. The rules for the competition are strict

Nick Rindo, *Captain Kirk and the Gorn*, 2013, alfalfa, amaranth, black lentils, brome-grass, brown lentil, brown mustart, buckwheat, flax, french lentil, green lentil, ivory lentil, kidney bean, mung bean, poppy seed, quinoa, red lentil, timothy, white clover, wild rice, yellow millet and yellow mustard.

Nick Rindo, *Mr Spock*, 2015, alfalfa, buckwheat, canola, flax seed, hairy vetch, kidney bean, white lentils, quinoa, red lentils, timothy, poppy seed and wild rice.

in that only horticultural crops suited or adapted for Minnesota are allowed. Lillian passed away in 2007 but left a lasting legacy of inspiration for artist Nick Rindo. In creating *Star Trek*-themed work, Rindo is drawn to the 'kitsch appeal' of producing immediately recognizable images in only seeds and glue and having them admired by the upwards of 200,000 visitors the fair receives each year.

Nick Rindo, *Uhura*, 2014, red millet, wild rice, poppy seed, red lentil, quinoa, alfafa, timothy, buckwheat, wheat, French lentil, white lentil, brown lentil, flax seed, golden flax and hairy vetch.

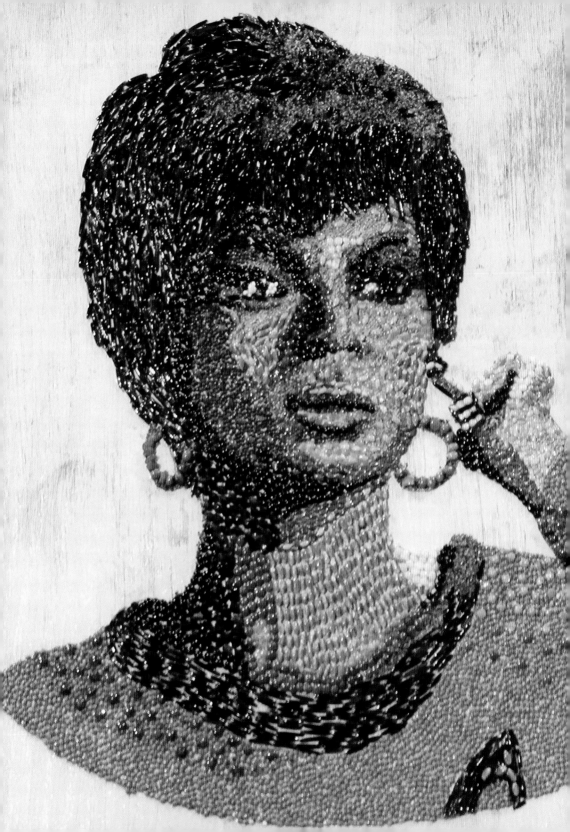

S

is for *Springerle*

❦

Most modern cookie lovers are familiar with embossed biscuits – the ubiquitous Oreo being the most notable in contemporary cookiedom. But when it comes to sheer beauty, none can compare to Germany's iconic anise *springerle*. This classic cookie is descended from the first imprinted biscuits from ancient Greece, decorated using wooden Eucharist stamps. By the fifteenth century, biblical scenes were pressed into *springerle* moulds, ostensibly to educate the illiterate. Later, portraits of royalty appeared on the creamy white, licorice-flavoured confection, as well as family coats-of-arms and city crests. To celebrate births and betrothals, eighteenth- and nineteenth-century *springerle* moulds showcased scenes of love, family and friendship. Today, you will find *spingerle* biscuits in almost every design imaginable.

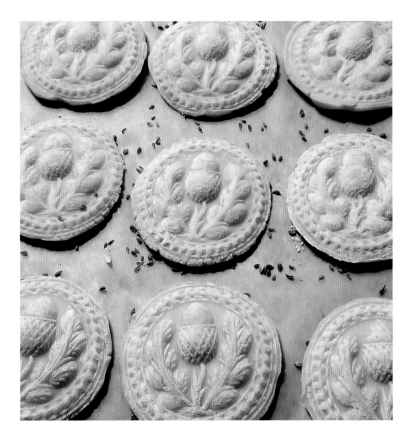

Lydian Sharp, *Springerle Thistle Cookies*, 2017, anise dough.

S

is for Sugar

~

Sugar is the single most diverse ingredient for foods artists. In its natural, unrefined state, it can be either a root vegetable – as in sugar beets – or bamboo-like reeds of sugar cane. Once processed and refined, its granular form is opaque and white, shimmery and pristine – like the sands of an albino beach. Melted, it is a crystal-clear syrup that takes easily to being tinted into any colour. Able to be transformed by the artist, it can be pulled or twisted into delicate, almost invisible threads or sinewy, striated ribbons. In its molten form, the same techniques as those used by glassblowers are utilized: blowing into a pipe to inflate a hollow globe, casting, pulling and cutting with paddles and shears. Moistened with a little water, granular sugar can be pressed into a mould to form elaborate shapes.

The history of sugar dates back to approximately 500 BCE in India when the conquering Persians discovered a 'reed which gives honey without bees'. After eggs, it is one of the oldest and most versatile of all

An example of sculpted sugar: Frank Vollkommer, *Fall Showpiece*, 2016, sugar has been blown, pulled, spun, moulded and pressed.

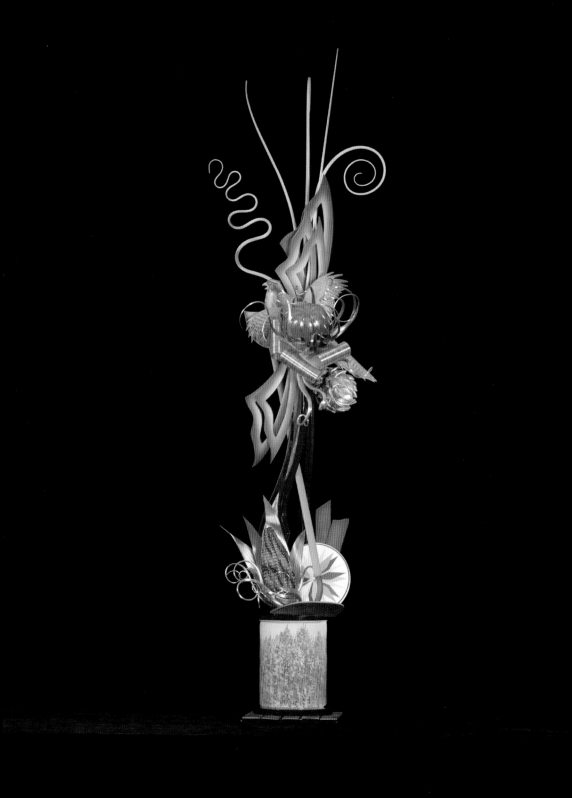

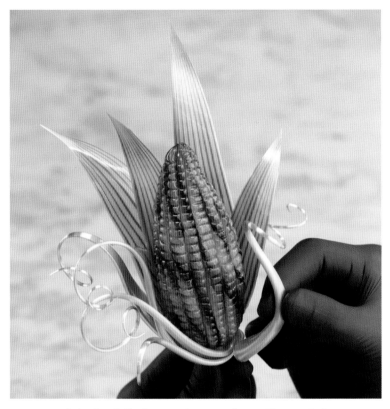

Forming the husk and silk of a corn cob in sugar, from Vollkommer's showpiece.

food items used in the creation of art. Crusaders brought sugar back to Europe from the East in approximately 1099, but it was so expensive, only the very wealthy and royal courts could afford the 'white gold'. Royalty would demonstrate their prestige at large feasts with so-called *shau-essen* – literally 'show food' – which were extravagant centrepieces made entirely of sugar. In a 1494 essay, *De conviventia* (On Conviviality), written by Giovanni Pontano, the importance of edible table decorations was directly tied to the sugar's increasing availability, the significance of making political statements in their design and the importance of displaying one's wealth in its usage.

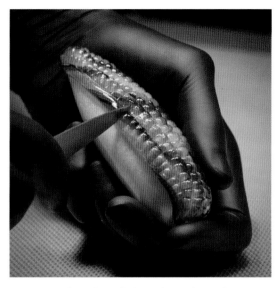

An ear of corn being fashioned entirely out of sugar
by expert hands.

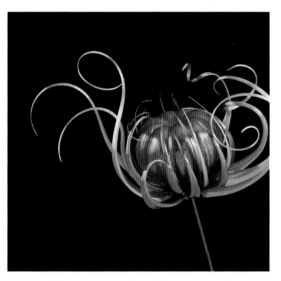

A decorative pumpkin will become part of
Vollkommer's large sugar showpiece.

Sculpted Sugar

Chef, teacher and sugar maven Frank Vollkommer doesn't have to worry about creating politically correct sugar centrepieces like his sixteenth-century counterparts did. But designing and assembling a formal showpiece for a competition can be even more harrowing. Creating a sculptural skyscraper that stands more than 1.2 metres (4 ft) tall involves techniques that include colouring, casting, pulling, blowing and spinning sugar. Competitions are won by masters of the craft like Vollkommer who can focus on themes, lines and architecture. A beautifully crafted sugar showpiece is designed to astound and hide the structural secrets of its construction and stability.

Delicate lollipops, or *amezaiku*, are a specific form of Japanese sugar craft that looks too beautiful to eat. Using techniques similar to flamework methods used by glass blowers, the artist, known as *ame shokunin*, mounts a small ball of molten sugar on a working stick. With tweezers and scissors, the hot, malleable sugar is pulled, bent, cut and shaped into intricate and life-like animals, usually in less than five minutes, before the sugar hardens. Once formed, accents and features are painted on with food colouring. From the 800s to the early twelfth century, the crafting of speciality sweets and candy was honed by those creating offerings for temples in Kyoto. The techniques flourished during the Edo period (1603–1868), when the practice moved beyond its liturgical origin into the modern era as a form of street performance.

Shinri Tezuka, *Amezaiku Goldfish*, 2015 , created from sugar made from millet and known as *mizuame*, translated as 'water candy', similar to corn syrup where the starch from the plant is converted to sugar.

Unknown Artists, *calaveras* or sugar skulls for *Día de Muertos*, 2016,
Hildago Market, Tijuana, Mexico.

Moulded Sugar

Day of the Dead – or *Día de Muertos* – is one of the most important holidays for Mexicans. Honouring the spirits of departed family members and friends, festivities involving eating, drinking and dancing commence promptly at midnight every 31 October and last for three days. Elaborate altars, or *ofrendas*, are erected in homes, adorned with vibrant gold marigolds, the favourite foods and beverages of the departed, pictures of the loved one and brightly coloured sugar skulls known as *calaveras*. Traditionally, *calaveras* are handmade by pressing moist sugar into a mould until it hardens. Now many buy pre-made, unadorned sugar skulls but still do the decorating with coloured foil, icing, beads and feathers for their *ofrendas*.

Using moulded and cast sugar, food historian and artist Tasha Marks commemorates European architectural motifs of English Tudor, French Gothic, German Baroque and Classical Greek buildings. Utilizing modern 3-D printing technology, Marks transforms a seventeenth-century sugar-plate recipe into designs she garnered from the famed Victoria & Albert Museum, melding the ancient and modern. As sugar sculptures were once used to demonstrate wealth and prestige, there is an irony that the permanence and legacy of stone and marble have been reimagined into polished shards of ephemeral sweetness.

Overleaf: Tasha Marks, *Alabaster Ruins*, 2017, moulded and cast sugar.

Portraiture

Working in everything from chocolate syrup to caviar, from peanut butter to jam, it was a series of portraits created in 1996, *The Sugar Children*, that brought Brazilian artist Vik Muniz to prominence. During a trip to the Caribbean island of St Kitts, Muniz met and became close to many of the children of workers in a sugar-growing and processing plant. Most artists start with a white canvas and add black lines or colour to generate an image. Counter-intuitively, Muniz worked on black paper, skilfully arranging grains of sugar to expose the black underneath: building mounds of pristine white to emulate the folds of a shirt, brushing away enough to expose the highlight of a cheek bone, or intricately moving a single grain or two to add a sparkling glint in a smiling eye.

Vik Muniz, *Valentine The Fastest*, from *The Sugar Children* series, 1996, gelatin silver print of granulated sugar.

T

is for Tea

As a trained physician, Ruth Tabancay is an anomaly as a food artist. She left private medical practice to pursue textile arts, invoking themes of geometry, science and anatomy in her art. The used teabags summon undertones of warmth and intimacy. Who drank that cup of tea? What were they thinking when they poured the water over the bag to steep out its gentle brew? Each teabag that is used becomes imbued with the inherent emotions that resonate with the artist and viewer on a personal level. For Tabancay, microscopic forms of bacteria and fungi swirl in her subconscious memories as a doctor, but manifest in the twisted and elegant creation of gathered and stitched teabags.

Ruth Tabancay, *Colony*, 2013, used tea bags, glue.

U

is for Udon

When it comes to Pop Art, Jason Mecier is a champ at noodling around. In this playful portrait, he showcases the title character of *Tampopo* from the eponymous 1985 'ramen western', a watershed film that helped establish the genre of food movie. With the artistry of a ramen chef, Mecier fashions the image from dried udon, a type of Japanese wheat noodle traditionally made in thick strips. This double entendre of the film's plot becomes a perfect vehicle for the visual pun of the young mother who, with the help of a cowboy hat-wearing truck driver, works to support her son by establishing a fledgling and ultimately much-loved noodle shop.

Jason Mecier, *Tampopo*, 2017, udon noodles.

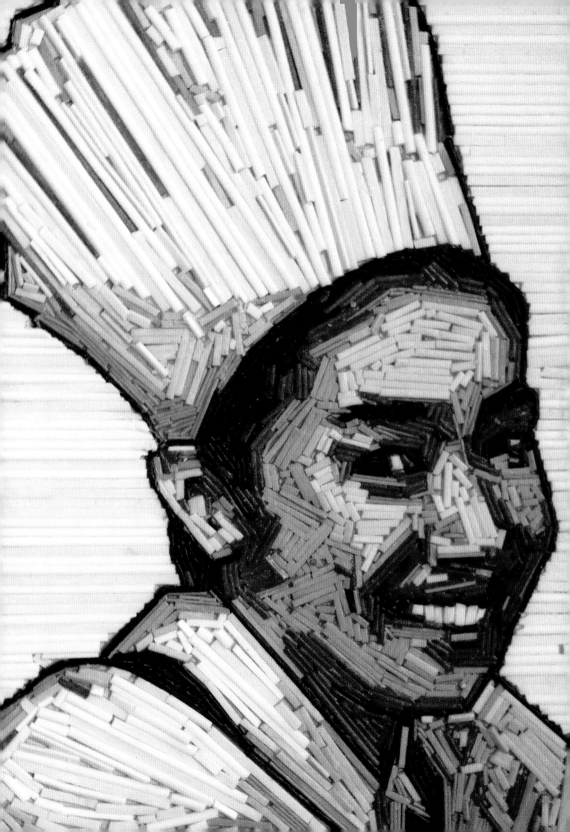

V

is for Vegetable

While chopping vegetables for dinner one evening, Margaret Dorfman held up slices of a squash to the light and marvelled at its interior symmetry and beauty. Inspired to preserve its splendour, she was also determined to find a way to capture and retain the splendours found in everyday foods. Farmers' markets and speciality produce stands in Chinatown are where Dorfman forages for her chosen medium. She scours for the perfect specimen of a bright-red beetroot, rich orange sweet potato, burgundy purple-red onion or exotic Asian produce such as bitter melon, *karela* or *dudhi*. Using similar techniques in the creation of ancient papyrus, Dorfman thickly slices and layers the produce in preparation for a lengthy curing and ageing process. To get the parchment thin enough to elicit the stained-glass hues and be formed, a custom-designed hydraulic press exerts 250 tonnes of pressure over a period of eight to ten days to form the vegetal paper. The shapes are then formed by hand and left to dry, ultimately creating light, luminously jewel-toned decorative vessels.

Margaret Dorfman, *Vegetable Parchment Bowls*, 2017, assorted vegetables.

W

is for *Wagashi*

Wagashi is a type of Japanese confection traditionally served with tea. Several dozen different types of wagashi are made, depending on their ingredients, styles and recipes. Most are made with combinations of sweet azuki bean paste (*anko*), sweetened rice flour that has been pounded smooth (*mochi*), sesame paste, agar (*kanten*) or chestnuts. Recalling shapes from nature – leaves, flowers or fruits – themes of the season in which they are prepared are invoked, from the colours of late autumn to the blush of a cherry blossom in spring.

Assorted Japanese *wagashi*, delicate confectionery made especially beautiful to be served with tea.

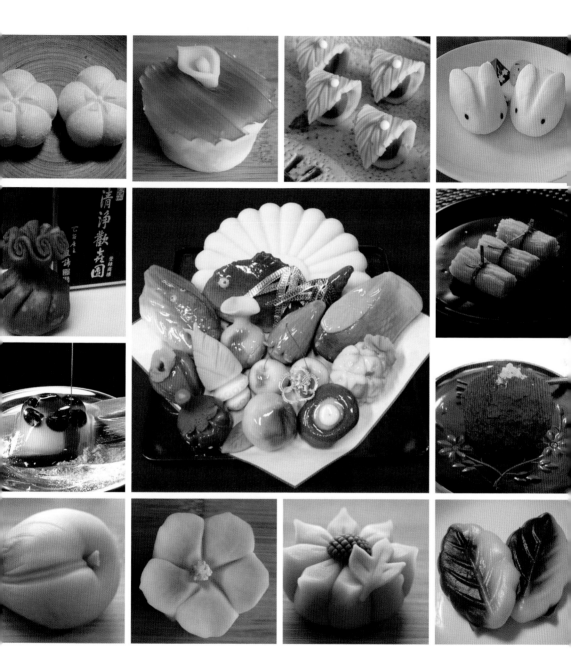

X

is for Xantham Gum

Xantham gum, along with 'ingredients' like sodium alginate, agar-agar, calcium lactate gluconate, iota and kappa carrageenan, isomalt, methoxyl pectin and hydroxypropyl methylcellulose, are part of the myriad of innovative ingredients used by molecular chefs. These mad scientists of the kitchen often prefer the term 'modernist cuisine', but what come from their gastronomic laboratories are nothing less than ephemeral masterpieces. Blending physics and chemistry with the culinary arts, the textures and tastes of everyday food get transformed into something that will surprise the diner with the unexpected and extraordinary. Sriracha sauce is transmuted into caviar-like spheres with agar-agar. Xantham gum helps bind parsley with champagne for an unusual sauce. Sweetcorn is transformed into shards of transparent glass. Garlic or pickles are metamorphosed into enticing, chewy caramels. To heighten the olfactory experience and provide dramatic performance art in which the diner participates, a chef may disperse the aroma of a dish with liquid nitrogen that is wafted tableside. Alluding to the classical artists these chefs are inspired by, many will use the very tools of a sculptor or painter, as in a ravioli being painted with a sauce, or a geometric Mondrian artwork made from cod and coloured peppers.

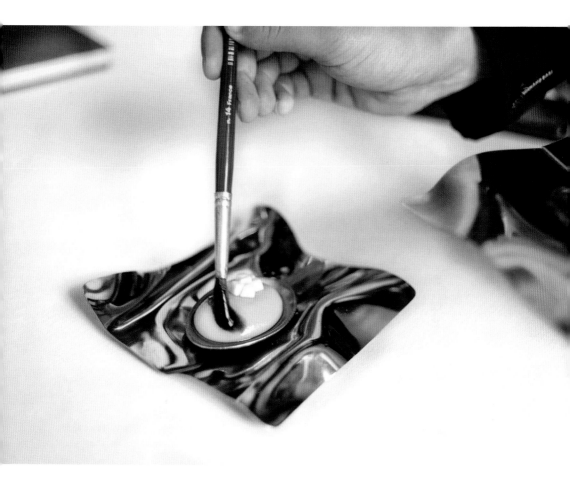

elBulli Restaurant, *14 Course, Japanese Ravioli*, 2011, spherified miso soup garnished with small cubes of tofu.

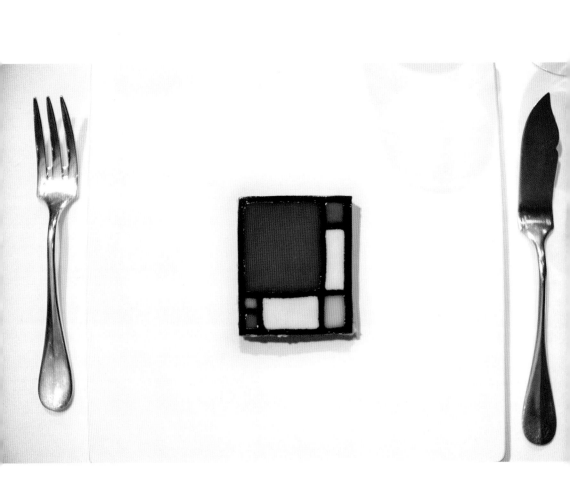

Sant Pau Restaurant, *2nd Course, Gastronomic Mondrian*, 2011, cod brandada, coloured peppers and black olive.

Alinea, *Lamb 86*, 2012, sixty garnishes made from 86 different components: almond, anise hyssop, apricot, artichoke, asparagus, basil, bay laurel, beetroot, black licorice, blackberry, blood orange, blueberry, brioche, capers, caraway powder, carrot, cherry, chive, coriander, cinnamon, clove, coffee, couscous, cumin, curry, dill, aubergine, endive, broad (fava) bean, fennel, fig, honey, king trumpet mushroom, lemon, Madeira, mint, oats, oregano, parsley, peach, pistachio, red onion, red pepper, red wine, rhubarb, rosemary, rum, saffron, sambuca, smoke, sorrel, spring garlic, star anise, tamarind, tarragon, thyme, tomato, walnut, white bean and yoghurt.

Y

is for Yam

Slightly sardonic and reminiscent of every family's favourite uncle, these character-driven yam carvings are the creation of landscape architect Steve DuBridge. He used to carve characters in wood, but over a dozen years ago – in the middle of a corn field in Amish country – he stumbled across a book devoted entirely to the art of sculpting in yams. There is an unabashed countenance of jocularity in these men of the tubers (for they are all men and never women!), engaging and jovial to the point of hilarity.

Steve DuBridge, *Portraits*, 2008–17, yams.

Z

is for Zucchini

Working as a chef in an Australian retirement home, Swiss-born Andy Branca-Mass likes to surprise his guests on their daily buffet with elaborate vegetable carvings. So impassioned has this chef become with the craft, that he has taken several trips to Thailand – the home of vegetable carving – for extensive masterclasses to pursue his passion. A meditative process and one he is thrilled to introduce to his new homeland, carving food is an art form that is considered to be something new and fashionable to Australia.

Andy Branca-Mass, *Zucchini*, 2017.

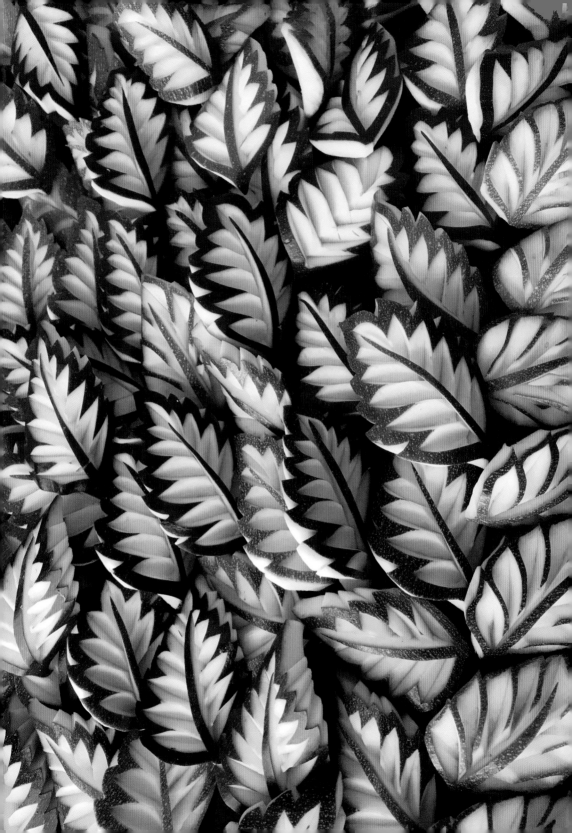

Select Bibliography

Abramson, Julia, 'Vegetable Carving: For Your Eyes Only', *Vegetables: Proceedings of the Oxford Symposium on Food and Cooking*, XXVI (2008), pp. 9–18

Adrià, Ferran et al., *elBulli, 2005–2011: Evolutionary Analysis* (London and New York, 2014)

Albala, Ken, *The Banquet: Dining in the Great Courts of Late Renaissance Europe* (Chicago, IL, 2007)

Bandi, Hans-Georg, et al., *The Art of the Stone Age* (New York, 1961)

Blumenthal, Heston, *Historic Heston* (London, 2013)

Bober, Phyllis Pray, *Art, Culture, and Cuisine: Ancient and Medieval Gastronomy* (Chicago, IL, 1999)

Brears, Peter, *Cooking and Dining in Tudor and Early Stuart England* (London, 2015)

Brown, Baldwin G., *The Art of the Cave Dweller: A Study of the Earliest Artistic Activities of Man* (London, 1928)

Carrington, Leonora, *The House of Fear: Notes from Down Below*, trans. Kathrine Talbot and Marina Warner (New York, 1988)

Cosman, Madeleine Pelner, *Fabulous Feasts: Medieval Cookery and Ceremony* (New York, 1976)

Dalí, Salvador, *The Collected Writings of Salvador Dalí*, ed. and trans. Haim Finkelstein (Cambridge, 1998)

Dupuy, Jean, ed., *Collective Consciousness: Art Performance in the Seventies* (New York, 1980)

Eckstut, Joann, and Arielle Eckstut, *The Secret Language of Color* (New York, 2013)

Frazier, Nancy, 'Salvador Dalí's Lobsters – Feast, Phobia, and Freudian Slip', *Gastronomica,* IX/4 (2009), pp. 16–20

Fuga, Antonella, *Artists' Techniques and Materials*, trans. Rosanna M. Giammanco Frongia (Los Angeles, CA, 2006)

Fussell, Betty, *The Story of Corn* (New York, 1992)

Gratza, Agnieszka, 'Spiritual Nourishment: Food and Ritual in Performance Art', *PAJ: A Journal of Performance and Art*, XXXII/1 (2010), pp. 67–75

Hudgins, Sharon, 'Edible Art: *Springerle* Cookies', *Gastronomica,* IV/4 (2004), pp. 66–71

Jackson, Eve, *Food and Transformation: Imagery and Symbolism of Eating* (Toronto, 1996)

Johnson, Diana, 'From Field to Frame – The Fine Art of Crop Art', *Gastronomica,* II/2 (2002), pp. 11–13

Kiple, Kenneth F., and Kriemhild Coneè Ornelas, eds, *The Cambridge World History of Food* (Cambridge, 2000)

Kirsch, Francine, 'Eat Me at the Fair – America's Love Affair with Food Installations', *Gastronomica,* XI/3 (2011), pp. 77–83

Klocker, Hubert, *Rite of Passage: The Early Years of Vienna Actionism, 1960–1966* (Cologne, 2014)

Krondle, Michael, *Sweet Invention: A History of Dessert* (Chicago, IL, 2011)

Levent, Nina, and Irina D. Mihalache, eds, *Food and Museums* (London, 2017)

Marinetti, Filippo Tommaso, *The Futurist Cookbook*, trans. Suzanne Brill (San Francisco, CA, 1991)

Monroe, Dave, 'Can Food Be Art? The Problem of Consumption', in *Food and Philosophy: Eat, Think and be Merry*, ed. Fritz Allhoff and Dave Monroe (Malden, MA, 2007), pp. 133–44

Myhrvold, Nathan, 'The Art in Gastronomy – A Modernist Perspective', *Gastronomica,* IX/3 (2011), pp. 25–8

—, and Maxime Bilet, *Modernist Cuisine at Home* (Bellevue, WA, 2012)

Notter, Ewald, *The Art of the Confectioner: Sugarwork and Pastillage* (Hoboken, NJ, 2012)

Pai, Shin Yu, 'Eat Art: Joseph Beuys, Dieter Roth, and Sonja Alhäuser at the Busch-Reisinger Museum', *Gastronomica*, II/1 (2001), pp. 4–5

Parzen, Jeremy, 'Please Play with Your Food: An Incomplete Survey of Culinary Wonders in Italian Renaissance Cookery', *Gastronomica*, IV/4 (2004), pp. 25–33

Paston-Williams, Sara, *The Art of Dining: A History of Cooking and Eating* (London, 1995 and 1999)

Perloff, Marjorie, *The Futurist Moment: Avant-garde, Avant Guerre, and the Language of Rupture* (Chicago, IL, and London, 1986)

Reed, Marcia, ed., *The Edible Monument: The Art of Food for Festivals* (Los Angeles, CA, 2015)

Rodinson, Maxime, et al., *Medieval Arab Cookery* (Totnes, 2001)

Sheehy, Colleen, *Seed Queen: The Story of Crop Art and the Amazing Lillian Colton* (St Paul, MN, 2007)

Slack, Susan Fuller, *Japanese Cooking* (Tucson, AZ, 1985)

Statton, Liza, 'Bittersweet Obsession; Ed Ruscha's *Chocolate Room*', *Gastronomica*, VI/1 (2006), pp. 7–9

Uchtmann, Daniel, *The Pleasures of the Table in Art* (Vienna, 2011)

Wall, Wendy, 'Shakespearean Jell-O – Mortality and Malleability in the Kitchen', *Gastronomica*, VI/1 (2006), pp. 41–50

Walther, Ingo F., ed., *Art of the 20th Century* (Cologne, 2016)

Watson, Katherine J., 'Sugar Sculpture for Grand Ducal Weddings from the Giambologna Workshop', *Connoisseur*, 189 (1978), pp. 20–26

Willan, Anne, *Great Cooks and Their Recipes, from Taillevent to Escoffier* (Boston, MA, Toronto and London, 1977)

Young, Carolin C., *Apples of Gold in Settings of Silver: Stories of Dinner as a Work of Art* (New York, 2002)

Zuffi, Stefano, *Color in Art* (New York, 2012)

Acknowledgements

There are no words that can adequately describe the depth of gratitude I feel towards Michael Leaman. I presented a flicker of a concept based on an obsession with researching and documenting food art, and he helped shaped it into something that would be fun and accessible to all. Heartfelt thanks to him and everyone at Reaktion, particularly Susannah Jayes, Rebecca Ratnayake and Amy Salter.

To all the artists who contributed to the book, I express my endless regard and awe for the art you create and for allowing me to showcase it here: Lorryn Abbott, Ghidaq al-Nizar, Daniele Baressi, Gil Batle, Andy Branca-Mass, Caleb Charland, Rares Craiut, Cynthia Delaney Suwito, DiCapria, Margaret Dorfman, Steve DuBridge, Klaus Enrique (double thanks for the cover art!), Leslie Griffin, chef Lauren Haas, chef Ciril Hitz, Sarah Kaufman, Takehiro Kishimoto, Judith Klausner, Robert Kushner, Blake Little, Carlo Marcucci, Tasha Marks, Lucia Matzger, Jason Mecier, Diana Alexeevna Milashevskaya, Shelley Miller, Linda Miller Nicholson, the Missouri Historical Museum, Vik Muniz, Marie Pelton, Gerhard Petzle, Karen Portaleo, Sarah Pratt, Nick Rindo, Leah Rosenberg, Ed Ruscha, Rachel Shimpock, Theresa Somerset, Ruth Tabancay, Daphne Tan, Shinri Tezuka, Mike Valladao, Jim Victor, chef Frank Vollkomer, Giselle Wang, Willard Wigan and Tina Zettel of Willow Tree Bakery.

To the many, many friends who helped me connect to artists I would not have otherwise known about or introduced me to food artists all over the world. Others who simply assisted in offbeat tasks I couldn't handle myself. And a handful were just there when I needed them: Ken Albala, Don Bacon, Bill Bayer, Maria Lorraine Binzet, Jeremy Buben, Philip Carli, Joan Chyun, Rachel Critelli, Stephen Durfee of the Culinary Institute of America, Nick Engel, chef Cheryl Forberg, Richard Foss, Masami Gan-fune, Gina Hall, Elathia Harris, Lora Hart, Dave Hill, Paul Homchick, Lisah Horner, Dianne Jacob, Jerry Kajust, Laura Kelley and Miranda Kelley, Cassandra Lee, Lauren Lottes, Lisa Lowitz, Dio Luria, Betsy McNair, Ralph Maldonado, Laura Martin-Bacon, Julane Marx, Ellen Matheson, Katie Moon, Erica Peters, Liz Rishavy, Shannon Ryan, Steve Sando, Amanda Scheutzow, Carol Shaw-Sutton, Pierre-Jean Texier, Lucy Vanel, Ayako Watanabe, Lance Wright and Tony Young.

Last but not least, to my family who mean more than I can say: Andrew Calman, Becca Calman, Daniel Calman, the entire Calman family and my sisters, Susan Wood and Jayne Flaherty.

Photo Acknowledgements

The author and the publishers wish to express their thanks to the below sources of illustrative material and/or permission to reproduce it.

Lorryn Abbott: p. 147; Ghidaq al-Nizar: p. 75; Alessandra Amandine: p. 55; Anagoria: p. 49; Copyright © R. J. Baddeley: pp. 136–7; Daniele Baressi: p. 47; Rich Baum: p. 15; Bouldernavigator: p. 133; Halina Busko: p. 107; Barry Callebaut USA LLC: pp. 123, 124, 125; Alessandro Caproni: p. 139; Caleb Charland: p. 89; Chronicle Books: p. 33; Rares Craiut: p. 105; Dana Davis: p. 161; Dicapria: pp. 97, 98; Steve DuBridge: p. 173; Klaus Enrique: p. 13; Anna Fox: p. 95 (top); Alejandro Linares Garcia: p. 130; Getty Research Institute: p. 22; Leslie Griffin: p. 45; Courtesy of Ciril Hitz: pp. 16, 50, 51; Hohenbuchau Collection: p. 8; Tan Hongziang: p. 118; Iowa State Fair: p. 57; Rizzel Javiar: p. 54; Kaldis Coffee: p. 77; Sarah Kaufmann: p. 65; Takehiro Kishimoto: p. 83; Judith Klausner: p. 121; Paul Kopeikin Gallery, Los Angeles, California: p. 101; Piotr Kuczynski: p. 27; Vladimir Kud: p. 28; Robert Kushner: p. 36; Michael Leaman: p. 52; Bonjwing Lee: pp. 17, 169, 170, Library of Congress, Washington, DC: p. 29; Edsel Little: p. 171; Carlo Marcucci: p. 119; Tasha Marks: pp. 156–7; John Maruskin: p. 59; Andy Branca-Mass: p. 175; Lucia Matzger: p. 78; Steve Mecier: p. 163; Metropolitan Museum of Art: p. 23; Diana